FREEDOM CRY

Women Fighting Trafficking

W0009196

Meri Crouley

DEDICATION

This book is dedicated to the women and children who are being tormented every day. GOD has heard your prayers and we are fighting for you! I also want to dedicate this to the people reading this book and getting educated to join this fight.

Don't curse the darkness… light a candle. Together we can help free the children who are crying in the dark for help.

ACKNOWLEDGEMENTS

I want to acknowledge and dedicate
this book to my three children;
Christina, Jeremy & Jason. I have often traveled
and been in the fight against these injustices.
You guys are always in my heart wherever I go!

Table of Contents

Dr. Meri Crouley

Dr. Meri Crouley is a speaker, author and minister who operates with a strong prophetic anointing. She travels all across the United States and internationally, speaking at conferences and crusades to compel the body of Christ and prepare them for another Great Awakening!

Her not-for-profit, Meri Crouley Ministries (www.MeriCrouley.com) is devoted to helping people find their purpose in life and is the umbrella under which she is able to pursue the many projects and callings the Lord has put on her heart, including.

Freedom Cry: Sex Trafficking in America

Meri is on a Quest and was given a call and a message to help the innocents, the women and children of our nation who have been victimized by a horrible blight on our society – child sex trafficking. Human Trafficking is a $150-billion-dollar industry worldwide. It is growing at an alarming rate and soon will surpass drug trafficking. Over 800,000 children are reported missing every year in the United States and many are victims of child sex-trafficking.

Women Fighting Trafficking

Meri launched the "Women Fighting Trafficking" website and campaign in Jupiter, Florida at the "We the People" rally on Memorial Day weekend. Women are joining forces throughout the land to take a stand and demand, **"ENOUGH IS ENOUGH"!** *The website is:* **www.womenfightingtrafficking.com**

Meri has been working on several motion pictures and is working with a team of people to bring forth a new motion picture studio which will bring content forth to change the culture. She has been broadcasting around the world her television program and Podcast "Now is the Time" via satellite, YouTube and various media platforms where Meri shares important explosive intel and interviews world changing influencers who will give you the real truth about what is happening around the globe.

She also will be giving prophetic insight into what's on the agenda in God's time table for 'THE GREATEST SHOW ON EARTH' being rolled out on the planet!

Meri has also worked with the youth around the nation with a series of concerts and events. The concerts were called "Youthwave" and now a new breed is rising on the horizon and they will be called "Regeneration" events. Meri's heart is to bring the generations together for a GREAT AWAKENING and the movement of God's spirit to change the world for Christ.

Her first book was released a few years ago by Deeper Calling Media entitled "From Glory to Glory: One Woman's Journey of Faith. Her heart is to go into the world with a message of light and hope to find the lost with the message of God's love! Meri is available to come speak at your church, convention, youth event, church or be interviewed on various media outlets.

CHAPTER 1

The Mission

By: Meri Crouley

I am on a mission. To stop child sex trafficking around the world. The purpose of this book is to tell the journey of how I got here. You will also hear stories of courageous women who have put their lives on the line and are telling their stories too.

The first three chapters will outline the plan. The Mission – The Movie – The Movement.

This chapter is dedicated to the Mission and why I jumped into the fight. Hopefully it will inspire you to jump into the fight too and make a difference!

The second chapter I will share about the "Freedom Cry" movie which was filmed in the United States. I had traveled into Thailand with my videographer and was doing a story about sex trafficking. We even went undercover with eyeglasses which had a camera built into the frames. It was dangerous but I wanted to see what went on behind the scenes.

Many young girls had been lured by these traffickers to come from the northern villages in Thailand where they lived and come to Bangkok and work to help their families. The mother and father of these girls often thought they were going to work at a hotel or restaurant. These families are often very poor and ignorant. When these innocent young girls (and sometimes young boys) come into Bangkok they are in for the shock of their lives. They are told they have to start sleeping with men who often come to Thailand as a sex-tourist destination. Chapter two

will describe in detail about the making of the Freedom Cry Movie and some of the stories involved.

And the third chapter will be on the Movement. How Women Fighting Trafficking was birthed and the call to the women of America and the world to jump into this fight and make a difference. There is a famous quote by Edmund Burke that says, "All that's necessary for evil to prevail is for good men (or women) to do nothing!" I decided I wanted to make a difference and we have the plan to do it!

The other remaining chapters are written by women who are actively fighting against sex trafficking on various levels. A few of the women had been sex-trafficked and are now free to tell their story. It is not pretty to hear, but very inspiring as to how they were able to finally break free from the trauma and rebuild their lives.

Some of the women are actively working with victims of child sex-trafficking and trying to rebuild their lives through therapy and God's love. And some of them are working to find these victims with the help of the police and other agencies who are putting their lives on the line every day to rescue these lost lambs.

This is how my story started on this journey to find these trafficked women and children. I have been working in the media mountain for the last twenty years. I have interviewed hundreds around the world as I have traveled into various countries. I have a television program and podcast called "Now is the Time".

Throughout the years there was a thread that seemed to be a common denominator among some of my interviews. Many of the women had been sexually exploited! One of the stories that really opened my eyes up was Heather Veitch. She is a very beautiful blonde woman and her story started out very innocently.

She took a job working at Hooters. Hooters is a restaurant/bar which has young women dressed in short shorts and t-shirts that say "Hooters" on it. Many men who frequent the establishment are not only there for the food – they are there to look at the girls. Heather took a job there and really liked the attention and tips she received while working there. Eventually she was approached to do some modeling and there were

"stars in her eyes". This is one of the big lures these traffickers and pimps use to get young girls enticed.

The modeling just happened to be wearing very little clothing! From there it went to soft porn and eventually she started working in a high-end strip club. Before she knew it, she was in porn and stripping. She was making quite a bit of money. But she knew deep in her heart that something was wrong! She had to drink alcohol when she was stripping! So many of these girls have to do drugs or drink in order to get through their shift.

Heather was working in Las Vegas and the year was 1999. Remember when everyone was worried about Y2K? There were many stories floating around that the world was going to end. All the computers were going to crash and people were stocking up on food just in case!

Heather told me in my interview with her that she started praying to God during this time in her life. She started dating a guy who was actually a decent person. He cared about her and after a few months of dating – they decided to get married! Heather started to turn her life around. She quit stripping and became a hairdresser. Her and her husband also gave their lives to Jesus and started attending a great local church.

They had moved into a cute home and she was working at a nice little hair salon. One day she was washing a girl's hair at the salon. The girl whose hair she was shampooing just happened to be a stripper! As Heather was rinsing the girl's hair she heard the voice of God, "You need to tell her about God!" Heather was shocked to hear the still small voice of God tell her to reach out to this stripper!

Heather said to me that she thought she was just going to forget about her past and live a happy life with her husband. But God had other plans! He wanted Heather to tell this young stripper her story and how she was touched by God's love and redemption. Heather was blow drying her hair when she finally was able to say a few things to her. She was bumbling around with her words as she was trying to tell her about Jesus. Finally, the girl had to leave and Heather rushed home. She felt so humiliated!

3

She went to the Pastor of the church she was attending and told him her story. Of how she had been a stripper in her past and how God had set her free. She then told the Pastor about what happened at the salon with the stripper who had come in to get her hair done and her humiliation in trying to tell her about God. To her surprise, the Pastor laughed! The Pastor lovingly told Heather that there were many girls in the church that had come out of that lifestyle. He said that "he had a plan". The plan was that they raised up a group of women at the church to go into the strip clubs! Inside the strip club they would then approach the girls individually. They would then pay money for their time and tell them about God's love and forgiveness. This would normally be the time where the girls would do their "lap dance" for the patrons.

But before they could implement this plan, they needed to be trained and "prayed up". And that's what they did! They started rehearsing what they were going to say inside the strip clubs. Most of the girls who were going into the Strip Clubs had been strippers at one time themselves – including Heather.

The first night that they decided to do this was on Christmas Eve. There were about eight girls who went into the Strip Club that night. Each girl chose one of the strippers to talk to. And then what happened was miraculous! Heather said that all of them were in the individual stalls where the girls would do their lap dance. But this time they were not doing lap dances for men. The sound in the area was all of these women were praying with the strippers. And all of their heads were bowed on Christmas Eve as many of them gave their hearts to Jesus! The best Christmas present ever – New Life!

Heather then went on with the Pastor and the church to start an organization called "JC's Girls, Girls, Girls". They would go to Adult Expos and have a booth. The girls would wear white shirts that said, "JC's Girls". That meant "Jesus Christ's Girls". And they had DVD's. with the girl's faces on it. Many of the men who came up to their booth thought that these DVD's had porn on it. But when they went home and popped it into the DVD player, it had a message from their Pastor sharing about how damaging pornography is and what they can do to be set free!

The Pastor then prayed for them to be delivered and set free! I'm sure they were shocked and some even angry! But many men were set free and started attending the church. And Heather and the girls were able to pray with many girls who were porn stars and strippers. There was much fruit that had come out of this!

Pornography has become an epidemic in our society. Gone are the days when men had to sneak into a Triple X rated movie theatre to watch porn. Now they can watch it right on their smartphone or computer. And the age that they want to seduce your child is eight years old! That's right! Eight years old! I'll go into this more in the chapter on the movie. – Freedom Cry.

One of the sections in the movie is "How porn fuels trafficking".

Heather is just one story that was highlighted for me to share with you. There were several more along the way. God started speaking to me that He wanted me to get involved. But I didn't know exactly what to do! How many of you reading this have felt the same way! Well, in the third chapter – the Movement, we are going to tell you what to do and "It's time to MOVE!"

And then I had the Dream! When I woke up from this dream I was shaken to the Core! God often will speak to people to get their attention through dreams. Joseph in the Old Testament had a dream of his brothers bowing down to him, Joseph and Mary were warned in a dream to flee to Egypt to protect Jesus from Herod, and many examples in the Bible show God leading people through dreams to direct them and get their attention. The dream I had that night got my attention!

I was riding with Jesus on a beautiful white horse! We were riding very fast in the green pastures and countryside. It was a beautiful, sunny day! I was holding onto Jesus with my arms around His waist. I looked over to my right and I saw a herd of sheep grazing on some lush, green grass. These sheep were very fat and healthy looking!

I smiled and asked Jesus, "What's that Jesus?" For some reason I felt compelled to ask Jesus that question. I could plainly see that they were sheep and grazing in green pastures. But what Jesus answered, startled me. Jesus replied, "That's my church! But I'm not there! Will you go with me to where the other sheep are?" I immediately answered "Yes, I will go!"

We kept on riding very fast for quite some time until we came to a thicket and we got off the horse. We started going down a steep embankment into the dark heavily wooded thicket.

I almost fell several times but Jesus steadied me with his hand. And then we were at the bottom and came to a clearing. I'll never forget what I saw!

I saw sheep! But these were not the fat, healthy sheep all huddled together eating lush, green grass. These sheep were emaciated! These sheep were in snares! These sheep were broken and bruised! And they all felt really "baaaaaadddddd". And they were all scattered and isolated.

One sheep was in a snare over to the right next to a large tree! Another sheep was twenty feet away by some shrubs. And they were scattered throughout the thicket. Isolated, broken, forgotten and lost. Lost lambs without a shepherd!

I will never forget what I saw Jesus do next! He walked over to one of the most miserable looking sheep in the snare. He lovingly reached down and gently opened the snare where the wounded sheep was trapped. He then gently removed the broken sheep from the snare and lovingly picked up this broken lamb and cradled her in his arms. He then rolled back his head and laughed! He wasn't laughing at this poor little sheep. Jesus was ecstatic that he rescued one and had set her free! He came to set the captives free!

He then lovingly turned his head and looked at me and said, "Shepherd Girl, Help me!" I looked at Jesus with amazement and shock. And then I started to move and do what I saw Jesus do – set these broken sheep free!

Jesus and I were laughing and having so much fun! We kept opening up more snares and freeing more sheep. The sheep were so happy that we were freeing them! We started binding up their wounds from the snares. And finally, we had rescued and recovered all of them in that thicket! I was tired but felt very fulfilled that I was able to help Jesus!

At the end of the dream, I was sitting in the front of a big wagon train with Jesus and Jesus spoke again, "Go into the world and find these lost sheep, Shepherd Girl. You are called to set the captives free too!

Freely you have received – Now Freely Give! And he smiled at me as a tear rolled down his cheek. "Many are called – but few choose the Call!" And then I woke up!

I sat straight up in bed and was stunned. The Dream was very clear to me what I was to do!

Psalms 23 is one of my favorite passages in the Bible. Many people have memorized this Psalms.

> *"The Lord is my Shepherd; I shall not want. He makes me lie down in green pastures, He leads me besides still waters, He restores my soul. He guides me along the right paths for His name's sake. Even though I walk through the valley of the shadow of death, I will fear no evil. For you are with me, your rod and your staff they comfort me. You prepare a table before me in the presence of my enemies. You anoint my head with oil; my cup overflows. Surely goodness and mercy will follow me all the days of my life, and I will dwell in the house of the Lord forever!"*

Jesus was calling me on a mission to set lost people free! They can't get themselves out of these snares. We need to go and find them! We need to rescue these women and children from these predators that prey on the innocent.

In **Matthew 18:12-14** the Bible says that Jesus will leave the ninety-ninety to find the one sheep that is lost. He knew the others were safe in the green pastures huddled together. It's the one who wanders away who is susceptible to the wolves to become prey.

In my story I shared earlier of Heather Veitch and going to the Strip Clubs – this was an example of going and finding these lost sheep. They put together an "action plan" and started to move to make it happen. And many of these girls were restored and redeemed. But they had to GO!

Jesus told us in **Mark 16:15** *"To go into all the world and preach the Gospel".* The Gospel is the good news. We all have sinned! There is none righteous – no not one!

Will you go with me on this mission! Will you go as Jesus asked me and help us find them!

Human trafficking has become an epidemic in our lifetime. Human Trafficking is a one hundred fifty-million-dollar industry worldwide.

It is estimated internationally there are between 20 million and 40 million people in modern slavery today. More than any other time in history! There are over one million children in America which are reported missing every year.

Estimates suggest that, internationally, only about .04% survivors of human trafficking cases are identified, meaning that the vast majority of cases of human trafficking go undetected.

Reports indicate that a large number of child sex trafficking survivors in the US were at one time in the foster care system.

The average age of a teen entering the sex trade in the US is 12 to 14 years old. Many victims are runaway girls who were sexually abused as children.

I'm telling these statistics for a reason – TO GET YOUR ATTENTION! This is our Mission! We need to get people involved and take ACTION! Will you jump in and help us? Can you hear them pleading for help? Together we can make a difference! Thanks for being part of the DREAM TEAM that God is raising up across America and the world!

CHAPTER 2

The Movie

By: Meri Crouley

In this chapter I am going to be talking about the making of the Freedom Cry documentary and how it got its beginning and the journey on the way. It's an important part of my story and my fight against sex-trafficking.

I have been involved with producing content for television for over twenty years. It's always been a passion of mine since I was in high school. It's interesting to look back and see how God prepares us for what He has called us to do. If some of you reading this book don't know what you are called to do in life – then you need to look at what your passions are. God will often put those desires inside of you and you need to follow your heart. God said in

Psalms 37:4

"that if you would delight yourself in the Lord, and He will give you the desires of your heart."

It was in May of 2017 that I was invited to UCLA and do some interviews at an event for Justice Speaks. Justice Speaks was founded by Jonathan and Sharon Ngai several years ago. They are both Pastors of a church in West Hollywood called Radiance International which is also a House of Prayer. I have been involved with their organization for several years and leading one of the prayer watches.

Justice Speaks is part of their ministry which helps educate people about sex-trafficking and what you can do to prevent it. They often travel to Thailand and go into poor villages and educate them. These traffickers will come into the smaller, poorer villages and lure these innocent families into sending their teenagers into the larger cities for work. These families cannot make ends meet and are very poor.

They are presented with options that their children can be working in a hotel or business which seems reputable. The promise is that the family member working will send back the money to help the family. This is such a temptation because they are poor and the money is much needed to help sustain the family.

But the tragedy is that when the gullible family accepts the offer – it turns into a tragedy. The young girl (or boy) will go down to Bangkok or some other larger city in Thailand. But instead of the promise of working in a hotel or reputable establishment for their labor, they are forced to sleep with men who come to Thailand as a sex-tourist destination. Sometimes as many as 15 times per day! The traffickers are getting rich but only a small amount goes back to the family. And often the girls are never heard from again! They are lost in the jungle of the large city and fall between the cracks. They now are victims of being lured into sex trafficking.

Jonathan and Sharon Ngai started taking teams of people over to Thailand on missionary trips to expose what is going on to the villagers. They go into the schools and work with the children and teach them about Jesus and God's word. There has been much fruit that has come from their work in Thailand.

Now let me get back to my interviews at UCLA for the Justice Speaks conference. They had booked one of the conference rooms at UCLA for the full day on Saturday. There were many people coming and sharing their stories and how God redeemed them from sex trafficking. One of the women that I interviewed was named Harmony.

Harmony had quite a story to tell. I brought my video camera, microphone and camera person with me to help with the shoot. We filmed her in an empty classroom which was set up for interviews that day. When the camera started filming - I was amazed to hear her story.

Harmony was raised in Los Angeles in a very dysfunctional home. She was around 13 years old when she was lured into human trafficking. She had a brother who was a few years younger than her. Her mother was not very responsible and decided to take a trip overseas with her boyfriend. And she decided to leave Harmony and her brother at home with no adult supervision. This was a recipe for disaster.

Harmony related her story to me about how she would go to the grocery store. She had no money and she was hungry. She often would steal food for her and her brother just to keep them alive. One day she happened to run into an older man who noticed her situation. He told Harmony he could help buy her food and help her! That was music to Harmony's ears! But the problem was – there were strings attached. Eventually this led her down the road of trafficking.

But Harmony's story does have a happy ending! Through a series of miracles, she was redeemed and restored. She now has a non-profit organization called "Treasures" where she helps recover and restore broken young women out of sex-trafficking. God turned her scars and helped make her into a star! She shines bright for Jesus and is helping find lost treasures by God's grace.

I interviewed several more people that day with amazing stories. But Harmony's story stuck with me. I just couldn't believe that this was happening in America! My heart went out to these innocent children who were being preyed on by people for monetary gain!

I went to a meeting that night with some producers in Los Angeles. It was a new group which had started for people in the film industry who were wanting to make connections with other like-minded people. We were all sharing with each other what we were working on currently in production. When it came my turn to share, I mentioned that I had just filmed a short piece at UCLA on sex-trafficking.

Immediately the women who was running the group told me that I should do a documentary about sex-trafficking! She went on to tell me that there were many media outlets that would pick up distribution on films of this nature. As I went home that night – the wheels in my head started spinning! Did God want me to do a documentary?

Was he calling me to help highlight the plight of these innocent victims?

I decided to pray and wait on God about what I was to do. I have done many television interviews over the last twenty years! I was also working on a motion picture biopic movie about the Jesus Movement and Lonnie Frisbee. We had developed the script and were working on getting into the next stage of development. But a documentary?

As I prayed, I felt a "green light" to go forward from God. And I started taking immediate action towards that project. As I discussed in the first chapter, I decided to go to Thailand with Jonathan and Sharon Ngai of the Justice Speaks organization. I brought my videographer, Dennis Moore, to Thailand with me and we were excited to get some great footage for this documentary.

I will never forget that trip! There are many men from the United States, Australia, Europe and around the world who come to Thailand as a sex-tourist destination. Dennis and I got some great footage interviewing people who were working to help these victims in Thailand. Annie Dieselberg of Nightlight was one of those people.

In 2005 NightLight began to address the lack of opportunity for women trapped in Bangkok's sex trade by providing them with a viable alternative means for supporting themselves. NightLight quickly grew into two branches: NightLight Design, Co. Ltd., the registered jewelry business offering holistic employment, and NightLight Foundation, the non-profit branch focusing on holistic intervention for women, families and communities affected by the global sex industry.

Annie took us around Bangkok and started teaching us about the sex trade in Thailand. She was very helpful and insightful as to where to go and how we could capture footage for the documentary we were producing.

One night Dennis and I even went into one of the nightclubs. I had a special pair of plain glasses where I could record what was happening in the Nightclub by pressing a small button on the side. And some of the footage which was recorded was shocking. There were young girls up on a main stage with stripper poles randomly placed. It was in a bar setting

with tables placed around the main stage. People would come in and have a drink and watch the girls. Most of the girl's working in these clubs were topless with bikini bottoms on. They would be dancing seductively to the music and trying to make eye contact with various patrons in their establishment.

As I looked around the Nightclub, I noticed that one man was making a play for one of the young girls on the stage. The next thing I saw was the Manager of the Club arranging for the girl to go with this man. Typically, these young girls are taken back to the Hotel where the man is staying. Typically, they will be with this man for the entire time that he is in Thailand. But that is not always the case. Sometimes they will come back for a new girl every night! We got some great footage in Thailand. When I finally returned home after being there for several days – I was exhausted! It took me a few days to get over the jet lag. I prayed and asked God for direction in the making of the documentary.

One morning in prayer, I was very surprised by what I sensed God was saying to me. "I don't want you to do this documentary about Thailand – I want you to focus on America!" That was the strong impression I heard from God one morning after my devotions. Right then and there, I knew that I was given a directive and I needed to follow it.

Fred Paskowitz had been directing and editing my television show "Now is the Time" for over twenty years. I called Fred up and told him about what God had instructed me to do. Fred is an excellent Director/editor and won several awards for films he has directed in the past. When I explained to Fred what God told me to do – he was all ears!

We met for lunch and penciled out a basic outline of what we wanted to do. But the main issue was we needed the money to do this film! I could write two chapters about what we did to do that. But I'll give you a brief synopsis of what we did!

We had two Gala's called "The Freedom Ball". One was in Beverly Hills at the Five-star Boutique Hotel called L'Ermitage. This was a beautiful Hotel right in the heart of Beverly Hills and we were going to be on the rooftop that night. The L'Ermitage Hotel overlooks the beautiful skyline of Los Angeles, the Hollywood sign, and Beverly Hills financial district.

I had never produced an event of that stature before. I had done many events - but never a Gala! But I moved ahead with my plans for the Freedom Ball Gala and we got everything prepared for the big night – Friday, October 12, 2018. We had about 200 people there that evening in attendance. We had a red carpet with a step-and-repeat backdrop with some of the sponsor's logos on the backdrop. We had some celebrities in attendance and there was even paparazzi that showed up. There was an incredible silent auction with some great pieces of art and sports memorabilia.

My good friend, Kip Hyams of Great Productions, was contracted to do the sound and lighting for the event. We had a five-piece band which was playing great jazz music in the background as people were arriving and taking photo ops for the cameras present. People were taking their seats and everything was getting ready to begin at 7 p.m. Things were going swimmingly well and I was excited!

All of a sudden, I looked up and saw some dark clouds which had just literally rolled in! Just an hour before it was bright sunshine with no clouds at all. As I mentioned earlier, we were on the rooftop under a beautiful beige tent which was a canopy over us. But we did not put the sides down on the canopy because the weather had been superb and it was not supposed to rain.

The sound equipment and the band were not located under the tent. They were next to the wall so we could have more room for tables. There were a few raindrops that started falling! My sound man, Kip, told the band that they needed to stop as it was dangerous for them to continue playing with the electrical cords and equipment outside.

It was 7:00 p.m. and time for the event to start. I went up to the microphone along with my co-host Steven. We welcomed everyone to the Freedom Ball Gala and started talking about what we hoped to accomplish that night. All of a sudden there was a loud sound of thunder in the sky. Within seconds there was torrential rain with thunder and lightning. I knew we were in a spiritual battle and something supernatural was taking place.

There was a loud crack of lightning and it struck a transformer in the distance. We were watching a battle between heaven and hell. I stepped

forward and pointed my finger towards heaven and shouted "God, you're KING OF THE WORLD!" That was one of the directives I was given to do that night while in prayer earlier.

It was fifty years since Martin Luther King, Jr. had been assassinated on April 4, 1968. Alveda King, the niece of Dr. Martin Luther King, Jr., was supposed to have spoken that night. But her mother had recently gotten very ill and we were going to have a video presentation from her during the event instead of her being in person.

The crowd who was seated at the tables watched in amazement at this spectacular thunder and lightning storm in front of their very eyes. We were clearly watching an incredible display of God's majesty.

My sound man, Kip Hyams, was trying to cover the sound board with plastic. The band had quit playing and came under the tent with their instruments. The evening was quickly becoming very chaotic and I took action.

I started sharing with the crowd about sex trafficking in America and how horrific of a problem it was with over 800,000 children who were missing yearly in the United States. The crowd was listening but was watching the spectacular display in the background. The rain started to diminish and we had various people sharing their stories including Opal Singleton (Million Kids) and former trafficked survivor, Ashley Trevino.

At the end of the event, we had not raised much money for the documentary. But everyone had a great time and felt like they witnessed something miraculous in the skies. The waiters who were working that evening told me later that they had never witnessed weather like this before. One waiter had worked there for over fifteen years!

As I made my way back home that evening, I was a little discouraged! I put so much effort into this event and we did not have the money to make the documentary about sex trafficking – Freedom Cry. God then spoke to me and said, "I want you to "keep the ball rolling!". I got a strong impression to contact a venue down in Orange County where I had hosted an event a few years prior.

The next day I called the venue and scheduled an appointment the following week to visit. The person I had initially worked with was no

longer there. Another couple had taken over the venue and she was a lovely woman named Simone.

I drove over to the venue the following day and sat down with Simone and told her that I had just finished an event in Beverly Hills just a week earlier. I proceeded to tell her about the unusual lightning and thunderstorm which had occurred. I told her that I had sensed that God had wanted me to "keep the ball rolling". That I was supposed to do another event as soon as possible.

She looked at me and asked if I had a date in mind. She started looking at the calendar and she then told me that she had Friday, December 7th available. And it just so happened to be one of the evenings of the Boat Parade in Dana Point Harbor. I couldn't believe my ears! Normally venues on the Boat Parade route would be booked months in advance. But because she had recently taken over the venue and remodeled it, the date was still open.

I told her that I would be interested in that date. But I also told her that I didn't have any money to put down a deposit. She then asked me if I could come up with a deposit by November 15th. In my spirit I felt that God had wanted me to say "Yes!". By faith I told her that I could do that and we penciled in the date.

And the amazing thing about that date is that it was the 77th year anniversary of the bombing of Pearl Harbor on December 7th. God sure has a thing with dates, times and anniversaries.

I immediately started working on getting the invitations and social media going to promote the event. I called up a few friends of mine who owned businesses and one of them said she would buy two tables. When I went to her business to pick up the check, she ended up donating $10,000 towards the event. God had supplied the deposit which I had needed by November 15th.

We had less than a month to get this put together. But God had told me to keep it rolling so that is what we did! By the time December 7th rolled around we had sold out all the tables. That night we had a wonderful event and we ended up raising some money to start the movie.

But the real miracle came when a great friend called me up and told me she was selling her business. She told me she was going to donate a sizable sum toward the movie as a tithe from her business! I was blown away! God had come through in ways that I could not even have imagined. As we do our part – God will do His part!

I started putting together my shooting list with my director, Fred Paskowitz. Fred had been working with me for the last fifteen years on my television program, "Now is the Time" and was excited to get going on the project.

The first person that we interviewed for the documentary was Ashley Trevino. Ashley had been trafficked out of Los Angeles as a 14-year-old teenager! You will read about Ashley later in this book when she recounts what happened to her. It is an amazing story of how God will rescue these victims and give them victories. Ashley now is a successful businesswoman in Orange County, California. She now owns a very prosperous Bridal Boutique and shares her inspiring story on many media outlets around the world.

Fred and I went to her Bridal Boutique, and we did a three-hour interview with Ashley. It was amazing as the camera was rolling and Ashley was relating the things which had happened to her. In back of us were the bridal gowns which Ashley was selling in her store. God had truly turned her nightmare into a fairy tale.

The next journey in the making of the Freedom Cry movie was flying up to Washington State where we had several interviews planned all over the State. We flew into Spokane, WA, for a conference which HRC Ministries and Caleb Altmeyer were hosting. Caleb and his wife were working with Anti-trafficking and even had a consignment store where the proceeds from the sales was going towards housing for the victims.

We set up our cameras in their offices the next day and we had a group of people we were interviewing. The first interview was Mark and his wife Jill. Mark had been a pimp or trafficker. He then went on to share his tale. How he had gotten busted and went to prison for drug trafficking. He then went on to tell us how he got groomed inside the prison on how to be a pimp!

The older men in prison told him it's much better to sell women than drugs. If you get busted with drugs – you go to prison. But often with women – you will be able to get out of the crime. You see - many of the girls who get groomed into sex trafficking become attached to their trafficker. They call it the Stockholm Syndrome. Stockholm syndrome is a condition where hostages develop a psychological bond with their captors during captivity. Sometimes people who are trafficked or are subject to abuse can have feelings of sympathy or other positive feelings toward the captor. This seems to happen over days, weeks, months or years of captivity and close contact to the captor.

I had interviewed the District Attorney of Orange County, Tony Rackaukas. Tony told us in our interview that many of these young girls who get picked up will often jump out of the police car and run at a stoplight! They had been subjected to beatings and were often afraid. Many of these girls even have tattoos branded on them of their pimp's name. These girls will have various titles. The top trafficked victim is sometimes called "the bottom girl". She will many times recruit other girls into the stable of girls for her trafficker or pimp.

As I spoke to Mark about his story about being a pimp – he shared with us how easy it was to get the girls. A pimp who grooms the girls by seducing them romantically is called a "Romeo Pimp". A pimp who uses force is called a "Gorilla Pimp". Mark was a "Romeo Pimp" and he shared his story of meeting Jill and how she became his "Bottom Girl".

Jill had decided to leave home and wanted to go to Vegas for some action. She met Mark and he eventually lured her into turning a trick for some quick cash. She was amazed how easy it was and eventually got sucked into the lifestyle. They were making tons of cash and started purchasing homes and cars. They were living the fast life! But it all caught up to them really quick and they got busted.

God did a miracle in their lives through a series of events. Mark went back to prison, but this time God started moving in his life. He started to read the bible and eventually gave his life to Jesus. Mark eventually got out of prison and married Jill. Now they are pastors and are helping

victims of sex-trafficking to get help and out of the life. Their story is in the Freedom cry documentary.

God had told me that he didn't call men to be "Pimps, pirates or pawns – but PRINCES AND KINGS!" Satan is luring many young people into seduction through pornography on the internet. It's a big trap and many are sucked in at a young age.

Caleb Altmeyer who hosted the conference then went on to tell us his incredible story. Caleb was raised in a Christian home. In fact, his grandfather and father are both pastors. He grew up in an environment which was very godly and conservative. One day he was at the neighbor's house, and they were watching television. They decided to flip through the channels to find something else to watch when they came upon a pornographic channel.

You see, his young friend had a grandfather who had a subscription to a porn channel on their cable television. Caleb told me in the interview that they were fascinated by what they saw. He was only eight years old at the time. This innocent young boy now had become captive to something very diabolical. Caleb's parents had no idea that he was being indoctrinated by visual stimulation that would greatly harm him.

Eventually it took over his life and his other friends too. But God had his hands on Caleb, and he eventually broke free from his addiction. He is now married and has a beautiful young family which he is raising. But he knows the cycle of abuse with pornography and how many men will inevitably seek out sex to purchase after watching enough porn.

I have interviewed many girls who say that the man purchasing sex will show them their cell phone and ask them to reenact what they are shown. The men become victims too! They are bound up with lust and often can't even get an erection anymore unless they watch pornography.

There were many other great interviews we filmed at this event in Spokane, Washington which HRC Ministries hosted. We wrapped up from filming that event and then made our way over to Seattle, WA and interviewed Amanda Hightower, the Director of a non-profit called REST (Real Escape from the sex trade). Rest was founded in 2009 by a small team of women who. Recognized that very few services existed to

meet the needs of sexually exploited individuals. The primary aim was to build relationships with people who were being trafficked in the local sex trade, learn what their true needs were, and serve as a bridge to critical services or resources.

Jacqueline was one of the girls who had been sex trafficked and now was working at REST. Her story was very different from the other girls I had interviewed. She grew up in a wealthy suburb of Seattle and at the age of 19 her mom told her to move out. She started couch surfing at various friend's apartments/homes and at a party one night met a guy named Brent. Brent was a handsome African American guy who she started dating. After a few months of dating, Brent took her out to dinner one evening. He was getting ready to go to college and was getting nervous. Brent told Jacqueline that he wanted to take her home to meet his mother.

The next day Brent took her over to meet his mother. But when she sat down to have coffee with her for a visit, the mother asked her something which she initially was surprised about! The mom asked Jacqueline if she could start prostituting to help put her son through school! At first Jacqueline was shocked!

But then Brent's mom started saying that she had been a prostitute and Brent's father had been her trafficker or pimp. "Don't you want to help your man?" was the verbiage she used to help lure Jacqueline into the life. Jacqueline continued to tell me that she said that she was very emphatic with Brent and wanted to do whatever she could to help him.

Brent's mom groomed Jacqueline into what kind of clothes to wear, etc., and what to say on the street when a car pulled over. They call this "walking the track". The first night she went out on the streets she was very nervous. In my interview she told me that she remembered the first car that slowed down and rolled down their window. She was also trained by Brent's mom on what to look for with customer's posing as John's but were really undercover cops.

The man asked her the prices and she then got into the car. They went into an alley around the corner and did their business. She then

went and took the money back to Brent. This is how Jacqueline got into the business. Very different from Ashley and some of the other girls. But nonetheless, it was still being trafficked.

In the movie "Freedom Cry" there are many stories which will cause your heart to weep! How can this be happening in America? It's time for us to wake up! It's time for you to step into the arena and make a difference. In the next chapter we will show you what you can do to help. This could be your child! This could be your grandchild! These innocent victims are somebody's child!

And we can help find them. We can help protect them. We can help heal their hearts. Please read the next chapter with an open mind and a willing heart! It's time to bring freedom to these captives, the opening of the prison to them who are bound. Jesus is going to help us find them.

Isaiah 61: 1-3

"The Spirit of the Sovereign Lord is on me, because the Lord has anointed me to proclaim good news to the poor. He has sent me to bind up the broken hearted, to proclaim freedom for the captives and release from darkness for the prisoners, to proclaim the year of the Lord's favor and the day of vengeance for our God, to comfort all who mourn, and provide for those who grieve in Zion – to bestow on them a crown of beauty instead of ashes, the oil of joy instead of mourning, and a garment of praise instead of a spirit of despair. They will be called oaks of righteousness, a planting of the Lord for the display of His splendor."

We finally completed the film, "Freedom Cry – Sex Trafficking in America" and are ready to take the "show on the road". Go across the nation with our mission and movement to help find these lost sheep who have become ensnared. Will you help us find them? Will you pray that God would release them from their prison? In the next chapter on "The Movement" we will share with you how you can get involved and make a difference.

God is raising up the "Dream Team" and we will take action to make a difference. Come be part of the team and make a difference to help and heal their hearts! The best is yet to come!!

CHAPTER 3

The Movement

By: Meri Crouley

We are at a time in history that is similar to the sixties. There were many movements which were erupting on the scene during that time in history. The 1960's saw the emergence of social movements around civil rights, opposition to the Vietnam War, Mexican American activism, as well as the first stirrings of gay rights.

One of the first movements which started was among students on the campus of the University of California in Berkeley. It became known as the Free Speech Movement. The movement was informally under the central leadership of Berkeley graduate student Mario Savio. But it all started when one young person, Jack Weinberg, refused to show his identification at the CORE table he was sitting at to the campus police and was arrested. There was a spontaneous movement of students to surround the police car in which he was transported. This was the form of civil disobedience that became a major movement in the sixties known as "The Free Speech Movement".

I'm writing about this movement because it was one person who sparked it! One person who will not back down from tyranny and speak truth against evil. We need women and men now to stand up against the status quo and speak up against this evil. One of those evils is child sex trafficking globally and your voice can make a difference.

Another movement which started in the sixties primarily through the voice of one man was the Civil rights movement. Dr. Martin Luther King, Jr. was an American Baptist minister and activist who became the

most visible spokesman and leader in the American civil rights movement from 1955 until his assassination in 1968. King advanced civil rights through nonviolence and civil disobedience, inspired by his Christian beliefs and the nonviolent activism of Mahatma Gandhi.

But there came a defining moment in his life when Dr. Martin Luther King, Jr. almost walked away from the movement. It was at the beginning of the Montgomery bus boycott. Rosa Parks had just been hauled to the police precinct for her audacity on the bus. And amid the electricity in the air, King emerged – the man of the hour, a confident new leader who would take on racism and injustice and violence, and surprisingly, in a spirit of confident, public non-violence.

Everyone thought the bus boycott would only last a few days. A few days, however, became many and passed over into weeks and months. That's when the death threats began. Chilling and cutting to the chase: "Call off the boycott or die."

Towards the end, as many as 40 such phone calls came in every day. And on one occasion, when the police had hauled him into jail for speeding, in the clutches of the police at last, he imagined himself on the threshold of being lynched. Fear descended on him like a fog.

It reached a boiling point on Friday evening, January 27th, 1956. King had just returned home from another long strategy session only to find Coretta asleep. He paced and knocked about, his nerves still on edge. And the phone rang and when he answered it, he heard a sneering voice on the other end: "Leave Montgomery immediately if you have no wish to die." King's fear surged; he hung up the phone, walked to the kitchen, and with trembling hands, put on a pot of coffee and sank into a chair at his kitchen table.

In his own words from his book *Stride Toward Freedom* he wrote:

I was ready to give up. With my cup of coffee sitting untouched before me, I tried to think of a way to move out of the picture without appearing a coward. In this state of exhaustion, when my courage had all but gone, I decided to take my problem to God. With my head in my hands, I bowed over the kitchen table aloud.

The words I spoke to God that midnight are still vivid in my memory. "I am taking a stand for what I believe is right. But now I am afraid. The people are looking to me for leadership, and if I stand before them without strength and courage, they too will falter. I am at the end of my powers, I have nothing left. I've come to the point where I can't face it alone."

At that moment, I experienced the presence of the Divine as I had never experienced God before. It seemed as though I could hear a quiet assurance of an inner voice saying: "Stand up for justice, stand up for truth; and God will be at your side forever."

Almost at once my fears began to go away. My uncertainty disappeared. I was ready to face anything."

Three days later a bomb blasted his house and his family barely escaped. "Strangely enough," King later wrote, "I accepted the word of the bombing calmly. My religious experience a few nights before had given me the strength to face it."

News of the bombing drew a crowd. A mob formed within the hour, all clenched jaws and closed fists. And they pressed up against the shattered house and shouted for vengeance. King mounted the broken porch and raised his hands. "We must meet hate with love. Remember, if I am stopped, this movement will not stop because God is with this movement. Go home with this glorious faith and radiant assurance." And the mob dissipated, their mood disarmed and their ears ringing with the message of gospel non-violence.

Some 11 years later, King spoke before an audience of his epiphany in the kitchen. "It seems at that moment, I could hear an inner voice saying to me, 'Martin Luther, stand up for righteousness. Stand up for justice. Stand up for truth. And lo, I will be with you, even until the end of the world.' I heard the voice of Jesus saying to fight on. He promised never to leave me, never to leave me alone."

We are at another moment in history that God wants to bring another movement! It's going to be a revolution. But this will be a revolution of righteousness. When enough people will stand up and speak the truth. Even if it initially only started with one voice. It will be the voice of freedom.

And this book is dedicated to women who have taken a stand to fight against sex trafficking in America and around the world.

In this book you will hear the beginning of another movement. A movement of women who have been abused and said "Enough is enough". When the Mother's get tired of their children being used and abused, they must rise up and make the Father's do what it takes to protect the children.

As I mentioned in the first chapter, I have been interviewing many people over the last 20 years. There was a thread that seemed to develop through my interviews with women who had come to know Jesus. Some of them had been abused by men and eventually even trafficked. I started working on the documentary and interviewing many women who had been trafficked. Things were going along well with the project and then Covid hit in March of 2020 and everything came to a halt. The nation was in a pandemic. Or at least the illusion of what the Media, Big Pharma and Big Tech wanted you to think!

The two weeks to slow the spread now had developed into a lockdown. In particular, where I lived in California. California was the first State to lock down. And Governor Gavin Newsom started acting more like a dictator than a public servant.

The Presidential election between President Trump and Joe Biden was underway. Trump had thousands of people attending his rallies while Joe Biden could barely draw a crowd. When the November 3, 2020, election happened, we watched in shock as we went to bed with Trump in the lead, only to wake up to see what happened in the middle of the night!

Miraculously Biden had pulled ahead! But there was something very suspicious that had happened in the middle of the night. Five counties shut down their counting at the same time. There was video footage of suitcases being pulled out from underneath tables. Massive fraud was happening right before our eyes. And the mainstream media was involved in this coup that happened in our country. They eventually proclaimed Joe Biden the winner of the 2020 Presidential race.

President Donald J. Trump invited the American Public to come January 6th, 2021, and make our voices be heard. There were thousands

who showed up that cold, winter day in Washington, D.C. I went with several women colleagues and we all rented an Air B & B a few miles away from the Capitol. We got up early and made our way over to the area where President Trump was going to deliver his speech. We waited in the long lines and eventually went through the security checks into the Ellipse where the rally was being held.

There were many people there and everyone was very peaceful. There were many other speakers there including Senators, Congressman, Rudy Giuliani, and several dozen more. Finally, President Donald J. Trump took the stage and gave a very long speech. There were many media outlets that were in attendance and were situated on a platform right besides where I was standing. President Trump spoke for a long time and finally told the crowd to march "peacefully and patriotically" down to the Capitol.

There was never any inciting of violence as many of the fake media are reporting. We all turned and made our way down Constitution Avenue. Halfway to the Capitol I received a call from my Pastor friend from Baltimore, Rick McDonald. In a very excited tone he told me, "They are storming the Capitol".

We all started praying and when we finally arrived at the front of the Capitol Building, there was no chaos. Mostly people gathering, praying and excited about having so many people in attendance supporting our Nation and President Trump. There were a few people who had climbed up on a statue in the front of the Capitol. But everyone was peaceful and in great spirits.

After a few hours we finally met up with Rick McDonald. He shared about what happened on the Capitol stairs that day. He told us that God had inspired him to go around to the back of the Capitol. There was a peaceful group of people milling around the Capitol when he noticed some vans pull up escorted by a police vehicle. A group of men exited dressed in MAGA clothing (Make America Great Again). They were dressed like Patriot's, but Rick had sensed something was wrong. They had loud rock music which was blasting from a boom box and made their way up to barriers set up in front of the Capitol.

27

There were not many Police in attendance that day! This group was inciting the crowd in the wrong direction! There were several Trump supporters who stepped in to try to appease the situation. He said it happened very quickly and that eventually this small group made its way into the Capitol Building.

I'm not going to expound on what happened that day as I was not on the backside of the Capitol Building. I was in the front of the building and saw some smoke and tear gas. But one thing I know is that it was not an "insurrection" as the media outlets were reporting on the news stations that day!

The reason I even bring up what happened that fateful day in Washington, D.C. is because it branded my heart into motion! We met up with some other Christians who were also at the rally and went to their Hotel Room which was a few blocks from the Capitol. There were several of us in their small hotel room and we linked our hands and lifted our voices up in prayer. We finally decided to go back to our Air B & B and invited a few of our friends over to our place and have dinner.

The Mayor of Washington D.C. Muriel Bowser had declared a curfew on the area and many of the stores and restaurants were being shut down. We had tried to go into Trader Joe's to get some groceries for our dinner and were told of the curfew. We finally were able to order some food at a local restaurant that received pick-up orders only. When I went into the establishment to pick up the food we had ordered, they had the television blasting out what happened at the Capitol.

I watched in disbelief at what they were reporting on the screen! The news outlets were telling people that an insurrection had happened at the Capitol! I looked at the restaurant worker who handed me the take-out food and I said, "I was there today and that's not what happened!" I only saw peaceful patriots who loved their President and country come out to stand up for freedom. I took the food and returned back to the Air B & B. We had a beautiful night of food, fellowship and prayer.

The next morning, we woke up and started to pray again! Our spirits were heavy and we felt an oppression in the atmosphere. As we prayed the Holy Spirit started speaking to us that we were to go to the Lincoln

Memorial that afternoon at 4:00 p.m. and do a broadcast to the world. That God was going to release a sound from that area which was so historic and significant of the times.

President Abraham Lincoln was the 16th President of the United States and endured many hardships in his life. He was President during one of the most tumultuous times in American History – the Civil War. During much hardship and perseverance, Abraham Lincoln issued the Emancipation Proclamation on September 22, 1862, during the Civil War which read:

"That on the first day of January in the year of our Lord, one thousand eight hundred and sixty-three, all persons held as slaves within any State, or designated part of a State, the people whereof shall then be in rebellion against the United States shall be then, thenceforward, and forever free, and the executive government of the United States, including the military and naval authority thereof, will recognize and maintain the freedom of such persons, and will do no act or acts to repress such persons, or any of them, in any efforts they may make for their actual freedom."

On January 1, 1863, the Proclamation changed the legal status under federal law of more than 3.5 million enslaved African Americans in the secessionist Confederate states from enslaved to free. There were 655,000 people who fought in the Civil War and it had finally come to an end! But America had to pay a great price for Freedom!

Standing at the Lincoln Memorial on January 7, 2021, we felt we were experiencing history once again. Our nation was at a crossroads! Would America survive? America is once again in a civil war. But this battle now is between good and evil! A nation where abortion had become legalized in 1973 and human trafficking had surpassed drug trafficking!

As our small team stood in front of the reflective pool facing the Lincoln Memorial ready to broadcast – we were going to let our voices be heard. We were going to release another proclamation. A proclamation to the world that God had released us from slavery and brought us into freedom through the blood of Jesus Christ!

There were five women and two men represented that day as the cameras started rolling. We each spoke a declaration from the Holy Spirit which we prayed and broadcast on all of our social media platforms to the nations. When we finished there were two young men, Emmanuel and Lion, who blew several blasts into the atmosphere.

In the old testament, similar shofars were blasted out several times after the children of Israel were told to march around Jericho and take the promised land for God's Kingdom. When the shofars blasted the walls of Jericho fell and the Israelites advanced and conquered their enemies. A great victory happened that day in Jericho.

I had sensed that something had shifted in the heavenlies as we proclaimed and decreed a victory over the nations from that location at the Lincoln Memorial. This battle was not ours to fight but the Lords.

2 Chronicles 20:15

He said, "Listen, King Jehoshaphat and all who live in Judah and Jerusalem! This is what the Lord says to you. 'Do not be afraid or discouraged because of this vast army. For the battle is not yours, but God's.

We were also standing on the same steps of the Lincoln Memorial where Dr. Martin Luther King, Jr. gave his famous "I have a Dream" speech, one hundred years after the Emancipation Proclamation. A man who pushed back fear and forged ahead through faith for FREEDOM!

Abraham Lincoln and Dr. Martin Luther King, Jr. both lost their lives for their voices of freedom! We need to be able to speak forth truth against tyranny, no matter what the consequences. This is America and our Founding Fathers of this nation built it upon freedom of speech and religion.

As we finished the prayer and proclamation broadcast from the Lincoln Memorial, I had a vision in the spirit of Dr. Martin Luther King, Jr., speaking on the stairs of the Lincoln Memorial on August 28th, 2963, over 58 years ago. I've watched his speech several times on the internet

and have always stirred to the core of my being with his words to the thousands of people who were listening that day. The last part of the speech is the most inspiring part which I will share with you now for your inspiration.

(Excerpt from the last portion of "I Have a Dream Speech" by Dr. King)

So even though we face the difficulties of today and tomorrow, I still have a dream. It is a dream deeply rooted in the American dream. I have a dream that one day this nation will rise up and live out the true meaning of its creed:

We hold these truths to be self-evident, that all men are created equal.

I have a dream that one day even the state of Mississippi, a state sweltering with the heat of injustice, sweltering with the heat of oppression will be transformed into an oasis of freedom and justice.

I have a dream that my four little children will one day live in a nation where they will not be judged by the color of their skin but by the content of their character. I have a dream today.

I have a dream that one day down in Alabama with its vicious racists, with its Governor having his lips dripping with the words of interposition and nullification, one day right down in Alabama little black boys and black girls will be able to join hands with little white boys and white girls as sisters and brothers. I have a dream today.

I have a dream that one day every valley shall be exalted, every hill and mountain shall be made low, the rough places will be made plain, and the crooked places will be made straight, and the glory of the Lord shall be revealed, and all flesh shall see it together.

This is our hope. This is the faith that I go back to the South with. With this faith, we will be able to hew out of the mountain of despair a stone of hope. With this faith we will be able to transform the jangling discords of our nation into a beautiful symphony of brotherhood. With this faith we will be able to work together, to pray together, to struggle together, to go to jail together, to stand up for freedom together, knowing that we will be free one day.

This will be the day when all of God's children will be able to sing with new meaning: My country, 'tis of thee, sweet land of liberty, of thee I sing. Land where my fathers died, land of the pilgrims' pride, from every mountainside, let freedom ring.

And if America is to be a great nation, this must become true. And so let freedom ring from the prodigious hilltops of New Hampshire. Let freedom ring from the mighty mountains of New York. Let freedom ring from the heightening Alleghenies of Pennsylvania. Let freedom ring from the snowcapped Rockies of Colorado. Let freedom ring from the curvaceous slopes of California. But not only that, let freedom ring from Lookout Mountain of Tennessee. Let freedom ring from every hill and molehill of Mississippi. From every mountainside, let freedom ring.

And when this happens, and when we allow freedom to ring, when we let it ring from every village and every hamlet, from every state and every city, we will be able to speed up that day when all God's children, black men and white men, Jews and Gentiles, Protestants and Catholics, will be able to join hands and sing in the words of the old Negro spiritual: Free at last. Free at last. Thank God almighty, we are free at last!

As you read those words, reflect on the magnitude of that message. This message was delivered during the middle of the civil rights movement. Dr. King would still have to face many imprisonments, racist slurs hurled at him, and bigotry. But because of the belief that freedom was ahead he forged on.

Our country is in similar circumstances at this time in history during the sixties. We are at the point of another movement that will impact history. But it will take all of our voices in unison singing a song of freedom and not surrender. We must be strong and not lose heart.

That day touched my heart and I was not afraid to continue to plow the ground ahead as a pioneer of truth. I flew back to California with a greater resolve to follow the path God was directing me to walk.

Now my message will get to how I started the Women Fighting Trafficking movement. I traveled to Tulsa, OK to be a part of the Clay Clark event, "The Health and Freedom" tour. This was the first of a seven-part tour which would travel to various locations in America with speakers sharing truth including General Michael Flynn, Mike Lindell, Attorney Lin Wood, and many doctors who were speaking forth truth against forced vaccinations and mask mandates. My friend, Anna Khait, was one of the speakers on this tour.

Anna was born in Russia and had lived under communism and socialism. She was speaking a message to a millennial generation not to be sucked into the false illusion of socialism. Anna had been a contestant on the hit reality series "Survivor" in 2016. She made it halfway through the show and was voted off the island.

That was a devastating blow for her but God supernaturally started drawing Anna by His spirit and she gave her life over to Jesus. She now is going to Bible school, hosting her own Podcast and bringing hope to thousands around the world.

I met many incredible men and women at that conference. True patriots who were not afraid to speak the truth! I then flew to Dallas to speak at several events before I made my way back to California.

God had released a fire in my spirit and I sensed that some new door was ready to open! A week after my return I received a call from a good friend who lived in Dallas, Linda Churchwell. She told me that she had felt that I was to speak at an event in Palm Beach Florida over Memorial Day weekend.

Christie Hutcherson is an amazing woman I had met in Washington, D.C. in December of 2020. She had formed a group "Women

Fighting for America" and was hosting the event that Memorial Day weekend with many speakers including: General Michael Flynn, Roger Stone, Patrick Byrne, Dr. Simone Gold and many others.

Linda had called Christie and told her that she felt that I was to speak at her event. Christie said yes and then asked what I would be speaking on. Linda called me back and told me I was invited to speak but Christie wanted to know what my topic would be. I immediately heard God speak to me "You need to talk about the trafficked women and children! I want you to help raise up the mothers and women to fight!"

And then my mind flashed back to my conversation with Detective James Rothstein. I met with him the previous year after my mother had died. He lived in St. Martin, Minnesota and had been the Mayor of that small community for a number of years.

I had heard about James Rothstein on several podcasts I had watched within the last year. He had an amazing story and I went down to interview him about his story. James Rothstein (aka Jimmy Boots) came to New York city in 1965 and on a dare, decided to apply for the New York Police Department. To his surprise, he actually got hired, and the Captain of the NYPD made him a detective over the Vice Squad. There was an area of New York which was known as the Minnesota Strip. The pimps were bringing girls from Minnesota to this area of New York and trafficking them. Since Jimmy was from Minnesota, the Captain thought he would be a good detective to try to infiltrate their trafficking ring.

When I sat down with Jimmy in his cozy house, I was intrigued. Sitting in front of me was a 78-year-old man who was a legend in New York. He got the name "Jimmy Boots" because he wore black cowboy boots. He began to share his amazing story with me.

Jimmy told me of how he began to go undercover in the streets of New York to bust these pimps. He was given an unlimited expense account to do so. He told me many amazing stories about how he eventually started taking down the trafficking network around the nation. He busted these pimps (or traffickers) one by one.

But then he shared with me the sordid details of wealthy men who would purchase younger children and teens. These younger victims were

known as chickens since their pubic hair was like young chickens. These men would pull up to these places known as "juice joints" in their limousines. You would then see the younger children exit and get into their limos and drive away. It was disgusting! Perversion at its highest level!

Jimmy started investigating the higher escallon of perversion. Every time he was ready to bust a higher-level politician or businessman, the Feds would step in and stop it. They would always say, "National security – we've got to shut it down!"

He started telling me about the pedophile rings which were highly organized. Young children who had become national stories including Johnny Gosch, Jacob Weatherly, Etan Patz and several other high profile cases. Jimmy said that these were sophisticated rings and they had some of the richest and most influential men and women in the world involved.

When he mentioned the name "Johnny Gosch" my heart almost stopped. I had interviewed Johnny's mother, Noreen Gosch, many years ago in Los Angeles. It was at a conference called "Preventing Abuse" and the Director of the organization was Tony Nassif. Tony had been working in the Anti-trafficking arena for many years. He had watched one of my television programs on a local affiliate in LA and emailed me. I eventually interviewed him on my television program, "Now is the Time".

Tony was an amazing man who touched many people's lives. He passed away a few years ago but is still alive and doing well in Heaven. Tony introduced me to Noreen Gosch and we went out to eat one night after the conference. I eventually interviewed Noreen and her story was incredible.

Johnny was twelve years old when he was abducted in Des Moines Iowa in 1982. He was a handsome young boy with chubby cheeks and freckles which sprinkled his face. He had a paper route and every morning he got up early to deliver those papers with his dog and red wagon. But one fateful morning Johnny never returned home! He was abducted! Noreen told me that she first noticed something was amiss when the phone started ringing. The neighbors were wondering where their daily newspaper was!

Noreen wondered what was going on because Johnny was very responsible. He always delivered the papers on time every morning! She started calling other neighbors and soon found out that they didn't have their papers either. She picked up the phone and called the police!

It took a long time for the police to respond. When they finally showed up at their house, to Noreen's amazement, the officer said that Johnny had probably run away from home. That normally they would have to wait for three days before they could do anything. This was not acceptable to Noreen. Johnny was a great kid and had never exhibited behavior of the sort to run away from home!

She ended up getting her own group together to search for Johnny, combing the parks and streets. To her amazement, the police captain pulled up with a bullhorn and told everyone to "go home". What was going on here?

Johnny never did come home and she had to hire her own private investigator. For years they looked for Johnny. Four times Johnny's plight was highlighted on the hit television series called "America's Most Wanted" with John Walsh. John's son, Adam, had been abducted and eventually his body was found. In his grief, John Walsh started helping other parents find their children. There were some clues that came forth that Johnny was alive.

On a bathroom stall, there was writing which said, "I'm Johnny Gosch and I'm alive!" Another time, it was the same message written on a dollar bill. Finally, after 12 years, she went on the Leeza Gibbons talk show and shared her story again. At the end of the show, Noreen tearfully pleaded for Johnny to come home. She also mentioned that she now was divorced from Johnny's father and was no longer living in the house they lived in when he was abducted. She then told Johnny that her address was listed in the local telephone book in Des Moines. Please come home Johnny!

What she told me next was chilling! Three months later, in the middle of the night, there was a knock at the door. Noreen looked out the keyhole and asked who was there. She then heard a voice, "Mom, it's me – Johnny!"

She opened the door and saw her son – Johnny. He was now grown and in his twenties. And he wasn't alone! He was with another young man around his same age. She brought Johnny and the other boy into her bedroom. Johnny nervously looked around and proceeded to tell his mom a chilling story. "Mom, I was abducted by an elite pedophile ring which goes up to the highest levels of government, entertainment and business." He then proceeded to tell her that he was abducted on the streets while doing his paper route. They bound and gagged him! He was sold to a man they called "the Colonel" in Colorado. Eventually he escaped and Johnny told his mother he was living on an Indian Reservation.

Johnny told his mother he had to stay underground and in hiding. That they would kill him and his mother if this information came to light. After a few hours of talking – Johnny and his friend left. Noreen did not tell me if she still stayed in touch with Johnny – I'm sure for their safety.

My thoughts came back to reality after hearing Jimmy saying Johnny's name as one of the pedophile networks he had investigated. Jimmy told me that he knew Noreen Gosch and that they worked together. Noreen even passed legislation called "The Johnny Gosch bill".

The Johnny Gosch bill was passed by the Iowa Legislature in 1984, which required law enforcement to immediately investigate missing-child cases where foul play was suspected.

"The parents were all responsible for lobbying Congress and for saying more needed to be done to protect children from violence and abduction," said Lowery of the National Center for Missing and Exploited Children. "What happened with Johnny Gosch is what opened the doors for the National Center for Missing and Exploited Children."

I talked with Jimmy for a few hours and then Jimmy looked me right in the eye and said, "If the mother's get involved – we can stop them!" I have a plan to do it! I blinked my eyes for a few minutes! Something in my heart was saying that I was to be a part of this. But it wasn't the time yet! Until now…. NOW IS THE TIME!

God wanted me to get the Mother's involved in this fight and for me to speak about this on Memorial Day weekend in Florida. I immediately took action! I started researching names for my movement. Many names involving 'mothers' were already taken. But when I did the search for the name 'Women Fighting Trafficking' – it was available. I bought the name on the internet and called my web designer and had her start working on this project. I only had a few weeks until Memorial Day weekend. I called Jimmy Boots and told him about the name I felt God had chosen for our movement. Jimmy said that in all of the years he had been talking about this with the women – this was the first time any action was taken.

I'm not taking any credit for this. The only reason I'm jumping in is because the Lord told me to do so. I got the web site launched under: www.womenfightingtrafficking.com. I also booked my ticket to fly to West Palm Beach, Florida. The last few days were a blur as I got everything ready for the launch. I also was introduced to a woman who lived in West Palm Beach named Karen. She called me and said that I could stay in her home and have a Women Fighting Trafficking meeting there! Wow! God was setting the stage for something BIG!

I got on the flight to West Palm Beach and Karen picked me up at the airport. That evening there were 12 women and one man who attended the first meeting. I shared the story about how God got me into the game and they all listened intently. At the end of the meeting I asked "Who wanted to get involved". There were 7 that raised their hands. We all got up and prayed in a circle for God to give us direction.

One of the ladies in the group spoke up and said, "Central High School is right up the street from here. That is where Jeffrey Epstein seduced many of the girls initially!" Jeffrey Epstein, the wealthy financier previously convicted as a sex offender, was arrested on July 6 on sex trafficking and conspiracy charges over allegations that he paid girls as young as 14 for sex and used them to procure other young girls between 2002 and 2005.

A criminal indictment unsealed July 8 in Manhattan federal court claims Epstein sexually exploited dozens of minor girls starting in 2002.

Epstein is said to have abused girls in his homes in both New York and Palm Beach, Florida. At both locations, Epstein recruited victims to give him "massages" that quickly turned sexual, prosecutors said. Epstein paid hundreds of dollars in cash, according to the indictment.

This stunning revelation from the women in the prayer circle stunned me. We were starting at the epicenter of abuse! We decided the next day to go over to the High School and pray at the front door of the school. We also did communion and prayed that this was the beginning of something that would sweep across America.

On Memorial Day weekend I did stand up on that stage and raise my voice! I talked about victims of trafficking, including Johnny Gosch. I told them about James Rothstein and his words to me about getting the mothers involved. I invited them to stand up and fight with me. Women Fighting Trafficking! It has now launched!

And we are just beginning the fight! Will you get involved? Will you stand up and be a voice for those who have been abused and silenced? Will you as a mother and woman rise up to the occasion and say, "Not on my watch!"

We are just starting to get the plan. We don't have everything in place yet! But we have started and that's all that matters! I have started raising up women to pray for 15 minutes per day to start. We will then be formulating more plans in the future involving legislation and creating laws which will stop trafficking too!

Please go to the website at: www.womenfightingtrafficking.com and get started to sign up to pray. It all starts with prayer! God bless you and we hope you become part of the team!

II Chronicles 7:14

"If my people, who are called by my name, will humble themselves and pray and seek my face and turn from their wicked ways. Then I will hear from heaven, and I will forgive their sin and will heal their land."

Annie Lobert

CEO & Founder, Hookers for Jesus

Author, Fallen

Annie Lobert is the CEO Founder of Hookers for Jesus, author, public speaker, TV talk show host, and an expert of sex trafficking. She is survivor of more than a decade of sex trafficking in Hawaii, Minneapolis, and Las Vegas. What started as a grass roots outreach to ladies in the sex industry soon became a non-profit. In 2005, Hookers for Jesus, was birthed. Annie moved into full time advocacy using her personal experience as a guide–and started mentoring and helping women who were being exploited by the sex industry. In 2007 Destiny House was officially founded. Destiny House and Dream House are a comforting safe place for women to live while healing from the serious trauma of being sex trafficked. Annie has been featured on many national, international, film, and tv documentaries such as the Dr. Oz Show, Dr. Drew Life Changers, Fox News Network, The Jesse Watters Show, Rachel Maddow, MSNBC, The Today Show, The Blaze, The Alan Colmes Show, Nancy Grace, Nightline, 20/20, Joy Behar Show, National Geographic, Tyra Banks Show, Investigation Discovery, Joyce Meyer's Enjoying Everyday Life, Patricia King Live, Pricilla Shier's The Chat, Life Today, Help Line TV, Dr. Murillo, ,700 Club, Jim Bakker Show, TBN's Praise the Lord, I Am Second Film, and many more. Annie has been heard on radio programs and interviewed in major news publications across the nation and world as well. Annie is the talk show host of Annie's Pink Chair. Annie's Pink Chair is aired weekly on TV in Las Vegas, NV, Chattanooga, TN, and Orlando Florida. Pink chair is also a podcast available on Apple, pod bean, Spotify, and many other platforms. Governmental organizations, judicial offices, police force trainings, hospitals, and educational systems, in addition to community groups and churches are effectively utilizing Annie's inside view and background to assist in educating the public and stirring them to action regarding prostitution and sex trafficking. She is currently on the Las Vegas Metropolitan Nevada Trafficking Task Force for victim advocacy, as well as the education & outreach committee.

Annie wrote a groundbreaking book called Fallen in 2015 about high-class escorting & it's deep ties to sex trafficking. She is currently authoring a 2nd book--stay tuned! Annie is happily married to the love of her life, Oz Fox. They were married on June 5th, 2009. Oz Fox is a founding member and current guitarist and vocalist for the heavy metal band Stryper.

annie@hookersforjesus.net

"Come, follow me," Jesus said, "and I will send you out to fish for people."

-Matthew 4:19

https://www.hookersforjesus.net
https://twitter.com/annielobert
https://twitter.com/hookersforjesus
https://www.facebook.com/#!/annielobert?fref=ts
https://www.facebook.com/#!/hookersforjesus?fref=ts

CHAPTER 4

Little Girl Lost:
How I Became a Hooker for Jesus

By: Annie Lobert

Laying on the floor in a dark room--I could only smell the stench of chopped cocaine on my hands and in my hair. I was fading in and out of consciousness…everything spinning around me. My heart was racing like a freight train, hurting, and pounding in my chest. At that moment when I heard the piercing sirens, I went blind.

What I now saw was jaw dropping. Like a movie reel, my life played itself in front of me.

Summertime in Minnesota playing, fishing in the lakes, and riding my bike. Playing with my brothers and sister in our Minneapolis suburban neighborhood on the sidewalks.

My dad was in the kitchen punching my mom. She was falling to her knees…trying to wipe the blood off the floor that was dripping from her nose.

Flashes of strobe lights and base pounding beats with all the eyes in the room on my body as I twirled around on stage at the strip club.

My boyfriend from Minnesota and I in Las Vegas. He was stalking me, controlling me, and slapping me. He was beating me and choking me almost to death. Black eyes, bruises, blood were dripping down my body and face.

Tall stacks of thousands upon thousands of dollars were being counted and poured through my hands from men who paid for sex as

I walked in and out of luxurious hotel rooms. Going up and down the fancy elevators and running from vice & security. Neon lights of Las Vegas blinking on and off--fading in the background.

Running away from my pimp, packing a bag, coming back, running away again. The vicious cycle repeating itself with several different abusive men in my life.

And then the end reel to complete the dramatized movie. There I was laying in the coffin. It was an open casket in a long dark room, with all the lights on me. I was dead with my hands folded across my body. I looked like a skeleton. My family & friends were coming up to the casket and shaking their heads in disgust and pity saying, "She was just a prostitute."

NO! That's not me! This cannot be happening right now! How the heck did this happen to me?

I grew up as a child believing that I was never good enough. My father was a strict disciplinarian with a background in the air force. I lived in fear, watching my dad have violent angry outbursts in our family. He would hit my mom while us kids watched helplessly…and then he would turn on us kids too.

I kept hearing the words played back in my mind: Failure. Imperfection. Not good enough. Reject. Ugly. Stupid.

Sexually abused at age 9 by a neighbor, those words drilled into my head even deeper.

When I hit puberty, my hormones were raging and I became addicted to chasing boys, parties and hanging out with my friends. I knew that I eventually wanted to go to college, get married and have my own family.

I had major insecurities and a severe lack of my own personal identity. When I went to high school--I instantly became the PARTY GIRL! I would organize kegger parties and drink a lot, because I wanted to be accepted by the "in" crowd. I attempted to become someone that I thought everyone wanted me to be. Why?

I didn't think my own father accepted me or loved me.

My boyfriend at the time cheated on me and I was devastated. There was a huge hole in my heart, a deep ache that I cannot describe. I felt that

44

my heart was broken completely, never to be the same. Now it was time for a full blown rebellion! Deep inside I was angry--upset with my boyfriend, mad at my father for not providing my needs (clothing, school & college support) and at myself for not being pretty or perfect enough.

I moved away from Wisconsin to Minneapolis to become a successful businesswoman in the corporate insurance business world. I would prove to my dad and everyone else who had hurt me, that I was worthy of love by making tons of money and moving up the corporate ladder. I was a workaholic, and got a full-time job at American Express, part time at Ichiban's Steakhouse and part time at Duluno's Pizza. My goal was to get my own car, apartment and save up some funds for college. Unfortunately, when you work three jobs, there is something that happens, major burn out. I needed a release, a way to let off steam. I started clubbing during the week and on the weekends after work. My friend and I both had fake identification, because the drinking age was 21 and we were both still teenagers.

One night my girlfriend and I were out dancing at a small club in downtown Minneapolis, and we met two men who looked like wealthy businessmen. They wanted to buy us a drink, and since we both weren't made of money, of course we said "Sure!"

My girlfriend started dating one of the men we met, and he romanced her with a beautiful Mercedes and a huge diamond rock on her finger. A few weeks later, she was calling me from Hawaii from the beach in a drop-top corvette.

And this is where the craziness all started.

We both were discussing how little our jobs paid us, and she told me that she discovered a "new" job that paid lots of money. I was all in! I flew to Hawaii that next week and for the first time in my life, I sold myself for sex. I was what many call "turned out."

What is "TURNED OUT"?

Turned out is either getting into prostitution for the first time or being forced. (Which would be sex trafficking if being forced)

This was the first time I ever sold my body for money. After I did it for the first time, I was hooked. I couldn't believe that men paid thousands

of dollars for a few minutes of pleasure. How easy?! How dumb they are!

After my life altering experience in Hawaii, I then went back to work in Minnesota to quit my regular job. I didn't consider myself a "prostitute" at all, but rather a "high class" escort. I was also an exotic dancer in between my new "night" job. After a few months, money took a turn for the worse....and eventually that led me to Las Vegas, Nevada. And then I did something that I later regretted, I invited my boyfriend I met at the strip club to come with me. He accepted and encouraged my lifestyle of stripping and prostitution.

The temptation of even BIGGER money tugged at my desires. I thought I could go to Vegas and get in and out quickly. The plan was to leave with my fortune so I could finally go to college. I was in for the most dangerous ride of my ENTIRE life. What was intended to be six months turned into a NIGHTMARE lifestyle of 16 years on and off.

You have to remember that ANYTHING out of balance will destroy you. I believed that my lifestyle was a life I had chosen because I wanted to fill that "emptiness" inside of me. Money was my answer to my poverty, and to every problem that I had. Why would a girl like me from Minnesota choose this way of living? Simple! was in complete rebellion of the hurt that I had experienced earlier in my life. No one "twisted" my arm in the very beginning, for my intense hunger for love and need for "revenge" would eventually consume me like a fire.

The allure and the illusion of the Las Vegas lifestyle of glamour, money, and sex had pulled me in the first moment I stepped off the plane. The "strip" looked so beautiful, enticing, and exciting...and the way that each casino flashed with sparkling lights on the outside beckoned at me with a voice saying, "Come here Annie!" With all the elaborate lighting, gambling, drinks, delicious food...then the possibility of meeting a millionaire client that would "rescue" me and take care of me, I could NOT resist.

I wanted to be "Pretty Woman" like Julia Roberts and have a prince come and take me away. My own sort of Richard Gere.

Here is the truth: When I started working in the sex industry, I liked it because it gave me a sense of security. I felt so glamorous and power-

ful. There was a certain "honeymoon" phase as a high-class call girl. The money, presents, parties, traveling, dinners, famous people calling, and I literally got lost in the "hype" of the moment! After all, everyone wants that "bling bling" lifestyle, right?

So, the very first night I worked, my boyfriend that I brought with me to Las Vegas told me to "break myself" (give him all of my money) when I got home from working all night. I immediately sassed him and told him NO. He took me in the back of my girlfriend's porch, choked me and beat me down so badly that I was bleeding out of my ears, eyes and nose. He shoved my face repeatedly in dog feces and yelled, "Do you know what time it is? This is pimpin' b#$%h! Time for you to BREAK YOURSELF."

I was utterly horrified, shocked, and heartbroken. I thought he loved me, but it was obvious he didn't. He apologized to me time and time again almost every time he beat me for getting out of line and disobeying the rules of the game, aka the pimp game. Believe it or not, I stayed with him for five years! I narrowly escaped with my very life. Then out of loneliness I hooked up with another boyfriend that started to also sex traffick me.

Five more years of hell.

Five more years of being stalked, locked up, and forced to sell myself. Five more years of being lied to, manipulated, and tricked into thinking these traffickers loved me and had my best interest at heart. Five more years of coercion.

Coercion is defined as: to compel to an act or choice & to achieve by force or threat.

What does that look like in trafficking?

Experiencing isolation, monopolization of perception, induced debility or exhaustion, threats, occasional indulgences, demonstration of omnipotence, degradation, and enforcement of trivial demands.

You see, coercion is a great tool for traffickers. Because in the absence of them even being around me, I felt compelled to submit and follow

the directions and live out the expectation that my traffickers demanded of me, out of fear and the need to be loved. This was super twisted psychological abuse, and it created such extreme post-traumatic stress in my life that I ended up experiencing severe anxiety attacks and lymphatic cancer.

I never wanted it to be this way. I never thought that coming to Las Vegas I would become a human trafficked sex slave!

That "glamorous" lifestyle took its toll on me, and that sense of security that I had, it turned out to be FALSE and I started slowly falling apart. Even though I looked like on the outside I had everything I ever wanted, the inside of me was dying.

My mask--the person that I pretended to be got thicker! I would make money, thinking it would buy me love, and then when that didn't work, I would buy myself material things so I could feel "important" and "loved" on the inside. This went on for many years...and guess what? If I DID get that happy feeling it was only temporary and then it started to turn into deep sadness because I knew no matter what I did to make myself "feel" better, it just wasn't working!

EMPTINESS.

I can't tell you how many nights I slept "alone" with a man in my bed. No one knew my secrets, my pain, and my inner shame. So, in the end I hated being an escort and exotic dancer--and no matter what people will tell you about this lifestyle, it really does rip you apart until you have absolutely NOTHING left--and, you lose your soul in the process!

Without even realizing it, now I had become a slave to the sex industry... but no one at the time could point that out to "Fallen" (me), for she had made the choice to do it on her own, the coercion and force came later.

Who was "Fallen" you ask? It was the name I picked as a stripper and escort girl. When you work in the sex industry you are told that you need a "dancer" name to separate yourself from your private life. Little did I know that "FALLEN" was slowly going to take over my ENTIRE life.

I was beaten, raped, kidnapped, strangled, suffocated, guns put in my mouth, hair cut off, tied up, gagged, put in trunks of cars, bones broken, spit on, kicked, pushed, stalked by crazy men, and during that time in Las Vegas I was sex trafficked for more than a decade.

This was done to the extent that I didn't even know who I was anymore. I literally had to become the alter ego named "Fallen" because she was strong, she could handle all of it without emotional and mental damage, she could get up after being punched and knocked out with no problem. She HAD to take over because she was the only one at the time that could keep that little girl Annie alive.

Sixteen years later, that fateful day came. August 2, 2003, I was lying on the floor and overdosed on cocaine. The reel of my life played before me.

I thought NO. This cannot be happening to me! As I lay there in complete darkness…all I could muster out of my heart was a sincere raw soul cry.

JESUS, please save me! I don't want to die this young--I promise I will never go back.

And I never did. It's been 18 years and I believe that I am a walking miracle.

Sober. In my right mind. Knowing that I am loved and completely forgiven by God. With Jesus at the center of my life.

I didn't know it at the time, but I had many experiences from trafficking, the symptoms of complex trauma. I had severe anxiety, fear, nightmares, distress that felt like a hurricane hit my heart and broke it into pieces. I was a hot messy mess! I knew I needed to surrender all my thoughts and emotions to Christ, even when I was afraid to trust Him. I took a leap of faith and decided to just do it. After all, what did I have to lose?

For the first time in my life, I sought Jesus for everything I needed, my healing, wholeness, physical health, shelter, food and transportation. While it was very challenging at times--it was an amazing experience. I read everything I could about how to become whole in every area of my life. I read my bible from cover to cover for the first time and during

that process God opened my eyes to who He was, the Father I've always wanted. A deep inner healing happened that made me realize who I truly was, and the incredible plan God had for my life. I will never ever forget the first time I truly realized that Jesus loved me, I felt like He was squeezing my heart & soul. I felt safe, secure, warm and cherished. It was better than any drug I'd ever tried!

I knew I had to do something to help my friends who were still being sex trafficked. I started reaching out to them and asking if they needed any help. I knew God was doing something very special, because most ladies responded they wanted to leave their traffickers and get out of the sex business completely.

That's when I decided it was time to form a non-profit (2005) called Hookers for Jesus. YEP. I said it.

Hookers for Jesus: Hook, Help, Heal and give Hope to ladies out of the drowning waters of sex trafficking.

I will teach you how to fish for people~Jesus Matthew 4:19

What started as a grassroots outreach on the Las Vegas strip, lead me to also establish a survivor led faith based safe house, (Destiny House, the first of its kind in USA) where ladies can come and heal from complex trauma, go through schooling, and get the education and training for the job of their choice. With our non-profit to date we have assisted personally over 5500 victims of trafficking with shelter, resources, and a way out of the sex industry. And coming soon, our second house Dream House, for independent living for ladies who have graduated Destiny House or a program like it. For more info, go to HookersForJesus.Net

I also produce and have my own TV show & podcast called Annie's Pink Chair. After doing so many interviews and documentaries on national and international film and television, and speaking on stages, I was offered to host an interview styled show where I bring on a variety of guests to share their incredible God stories of transformation and freedom. It's been incredible so far--and we are just beginning!

For more info, go to HookersForJesus.Net and click on Pink Chair.

And guess what? A prince came into my life in 2007. I got married in 2009 to the love of my life, Oz Fox, founding member of the famous rock band Stryper. I finally can understand what a real loving relationship looks like, something I was always longing for. And I truly believe that God in His sovereignty had a plan for all of this.

Even my bad choices couldn't interfere with what God was doing.

The enemy tried to use so much to destroy me. Before Christ I felt so much shame, guilt, fear, regret, sadness, loneliness, condemnation, and thought my life was cursed forever.

No mental health, psychologist, hospital, human being could help me when I first got out of the sex industry. But when Jesus came into my heart, this was a supernatural exchange of everything I needed so desperately. My shame for His beauty. My fear for His courage. My sadness for His joy. My pain for his healing. My brokenness for His completeness. My trauma for His stability. My chaos for His peace.

His peace was nothing like I've never had. Deep true peace, not just a passing feeling. The kind that makes you feel safe, secure, and cared for. Solid stability for the first time in my life! I finally had a real relationship with Jesus. And it wasn't religious--full of rules and legalism. No, it was a type of communication where I could come to Him about anything and know I wouldn't be judged or condemned. He built real trust, security, and confidence in me, and gave me a freedom and grace that I never thought was possible. And the most important? A deep love for serving others that were less fortunate. Because my life is not about me anymore, I'm here to guide others out of where I once was. I get to do what I love best, help others out of the darkness and into the beautiful light and love of Jesus.

You could say my life pre-Jesus was a total disaster and I was on the brink of death and destruction. But now I'm living a life of incredible purpose, passion, and incredible adventure.

Friend, I want to encourage you. We are not defined by our failures, who we used to be or the bad things we've chosen to do. We are defined by our character and what we decide to do with what we've learned--and who Jesus says we are. Conquerors!

When we invite Jesus into our messes and into our lives, He makes us brand new, gives us another chance and lets us start all over. How incredible! I look back now on all the bad choices I made & I see his patience, his mercy, and that He always had his hand on me, protecting me! me. He never let me go! They say only 1 percent get out of sex trafficking alive. I am a walking miracle! And if He could do it for me, He can do it for you!

There is so much more to this journey, and the real chronicle of my life in the sex industry can be found in the book I wrote about my life, Fallen Out of the Sex Industry and into the Arms of the Savior. Please read it to find out more details here: HookersForJesus.Net

Annie Lobert
Founder and CEO
Hookers for Jesus
Destiny House
Pink Chair

If you need resources or help, please contact us at 702-883-555
Speaking or media inquiries, please contact 702-883-5155

Ashley Nadine

Ashley Nadine is a business owner, an author, business consultant and Motivational Speaker located in Brea, CA. Her passion for fashion was discovered at a young age with her involvement in dance, creative arts and pageant shows. She has helped develop her natural gift to bring out the best in others. She is a firm believer in building one's self esteem and self-image at the same time. Ashley has a very powerful and inspiring organization called Limitless. Limitless is dedicated to helping encourage, inspire and motivate people to get on track. She has thrown numerous events including Fashion shows for great causes such as bringing awareness to Human Trafficking and building confidence and self-worth in many individuals. She has worked with America's Next Top Model and LA Fashion Week, is the Cover Star on Amare Magazine's "Heroes of Change" issue alongside boxing champion Oscar De la Hoya and was awarded as a "Modern day Hero." She has also been featured in LA Style Magazine in the "Most Influential " issue. Ashley works with numerous women to help them discover their confidence through style and mental encouragement. Ashley believes confidence begins in the mind first and that style is a by-product. She has many speaking engagements around the United States, helping encourage many to discover confidence from with-in and find faith in a loving God.

ashleynadine1@gmail.com

CHAPTER 5

Worth Dying For

By: Ashley Nadine

When I was 14, I met a girl, my age. She seemed fun and exciting to me. I loved making new friends. So, I asked my parents to spend the night over at her house. I was a great student, a cheerleader and my parents trusted me so they gave me permission to stay the night at my new friend's house. Little did I know, my life was about to take a turn for the worst. That night, once my friend's mom went to sleep, my new friend whispered to me "Let's sneak out. I know about this house party around the corner." We jumped the backyard fence around midnight and ran in the dark until we reached a street with strobing lights, loud music and cars parked up and down the whole street. My heart was beating so fast. It was my first time at a house party. When we walked in, my friend immediately met up with an older man and took off upstairs with him. She left me standing at the front door by myself.

Standing there alone, I was approached by a tall, dark and handsome man. He was trying to talk to me over the loud music and I couldn't hear him so he grabbed my hand and led me to a room. I was nervous but he was cute and my friend was nowhere to be found so I figured this is the place to hang out until she returns. He introduced himself, and began to serenade me with words I've never heard. He told me everything a young girl would want to hear. He told me I was so beautiful, how pretty my eyes were and that he wants to get to know me. I was instantly swept off my feet. I thought to myself, "This is going to be my husband. This is going to be the man I've been waiting for!"

A few months later, he asked me to be his girlfriend. He would pick me up in his nice BMW and drive me around fancy places. I remember thinking every day and hoping this could be the day he will tell me he wants to marry me. One summer day, he picked me up after school, and we drove for about an hour until we approached a neighborhood in the Hollywood Hills. He took my hand and pointed to one big mansion on the hill and said "You see that house Ashley? That's going to be ours one day." My heart was so full. I couldn't believe what I was hearing. The moment I had been waiting for was finally here! He said the home would be "ours."

We started to drive back down the hill until we stopped at a park nearby. He parked. The sun was starting to go down and he told me to get out of the car. I didn't hesitate. I mean I was just waiting for the proposal. As he came around from the drivers' side to the passengers' side where I was now standing, his hand came slapping me across the face as he told me "you're going to be working for me now. You will be making grown woman money."

Still in shock, I was introduced to 3 other men who were extremely intimidating; two of the men were fresh out of jail and the other was on his "3rd strike." I was so afraid of them. I was then instructed to take explicit pictures and they told me that they knew where my parents lived and if I told anyone, they would send those pictures to my parents and hurt them. My life was no longer my own. I was forced to audition on the Sunset Strip in Hollywood, California at a strip club and immediately hired that night. Every night I was told to give my money to my "boyfriend" who was now my pimp. I had no idea how or why I was doing what I was doing but I just knew I loved him and wanted to do anything to please him and keep him happy. He told me as long as I made him money, he was "satisfied." For years I danced at the strip club and lived a double life. My parents thought I worked as a cocktail waitress. When I moved out with my "boyfriend" before I turned 18, they were so worried and my dad begged me to leave that guy alone. "He's bad news." But at this point, I was so beat up, lost and broken. The abuse was so bad. One night one of the pimps broke a grey goose bottle over

my head and choked me until I passed out. There were two pimps who lived with me and my other friend who stripped and watched our every move.

One night, the abuse was so bad, the neighbors called the cops and my parents were called but I still didn't leave my pimp. I could see the despair in their faces. I will never forget the look in their eyes. It saddens me to this day. My life was so crazy. Men would follow me home, I've had guns to my head and have been so close to death many times. I still can't drink from a water bottle that I don't know isn't sealed because I've been drugged so many times.

One morning, I started feeling nauseous and morning sickness continued. As my tummy continued to grow, it became "too noticeable" at the strip club that I was pregnant. At this point, I was faced with one of the toughest decisions. Do I abort the baby and continue in this lifestyle or keep the baby and run away for the safety of my life and my unborn baby? With all this chaos going on, I decided to meet up with my friend Amanda from high school. There was something about her that I trusted. She was full of Love. When I snuck away and confessed everything to Amanda, she began to cry uncontrollably and told me she felt God's presence and love for me. She told me there was a God named Jesus who Loved me and if I kept my baby, he would provide and protect me. I cussed her out and went to work at the strip club that night because I wasn't ready to receive her message. Her words haunted me though. I kept wondering how can God love me? I'm so messed up, I hate myself. So I just went about my normal routine. When I got to work, I went to the back of the strip club dressing room and as I was putting my lingerie on for work.

As I took one last look in the mirror before going down to work on the dance floor, I looked at my reflection only for it to turn into an encounter. My image began to change in front of my face to a fatherly presence; a spiritual presence. I saw and felt God looking right at me in the strip club dressing room! God's presence was so HOLY that it frightened me but I could feel His love kept drawing my soul in. I ran out of there as fast as I could! Just when I thought God was done chasing me,

I got home to find there was an unknown book called "God's Promises for Women" on my dresser. I don't know how it got there! I opened it up and for the first time in my life, I read the word of God and the words said, "Ask and it shall be given, seek and you will find and knock and I will open the door!" At this point, I felt God was chasing me! I said God if you're real, I need you to show me. That's when I felt the love of God enter into my body and I've never been the same!

All the years of trauma, sex trafficking and abuse still affected me and I wanted healing. I decided to join a step study to celebrate recovery. To my surprise, the people were just like me! They had their own hurts, habits and hang ups and it wasn't a "fake Christian" atmosphere like I was used to at churches. I felt churches couldn't handle my reality as a stripper. My eyelashes were just too long for them I suppose.

I jumped in full time to celebrate recovery! I went every Friday night faithfully and step study on Thursday's. I was all in! I would hear old timers say "it works if you work it." And eventually started to see gradual changes in my heart. I could feel God's presence again and started trusting people, even my view of men began to change for the better. After giving my life to Jesus, I decided to keep my daughter, who has grown into a beautiful young girl. Her name is Leila. I started sharing my testimony and helping women who were sex trafficked out of the industry and leading them to Christ. One day I received a call from a lady named Maria who owned a bridal boutique. Maria was one of my previous sponsors from a fashion show I had to raise awareness for Human Trafficking. She called to ask me if I wanted to buy her BRIDAL Boutique!!! That one connection took my life to the next level as a new business owner and entrepreneur. I've been in business over 5 years now and still going strong! Jesus has restored my life, given me identity and purpose. but most of all showed me my WORTH. That I'm WORTH dying for!! And for that, I will forever be grateful and feel I owe him my life. My name is Ashley and I'm a redeemed, restored and grateful believer by the blood of Jesus Christ!

Thank you for letting me share

Christine Curtis

Born and raised (mostly) in Spokane, Washington and having experienced half of my life a tumble weed blowing in the end and the other half following Christ I have learned many lessons along the way. I still wonder sometimes why God chose me and blessed me with a rock of a husband, 3 lovely kiddos and a dream of a career. And then he reminds me that was his plan all along for me and for all his kids. I'm so grateful for my second chance in life and will always do my best not to take it for granted. May I show forth Gods love to the world and give him all the glory, always!

cjcurtis1985@live.com

CHAPTER 6

Falling for Winter

By: Christine Curtis

"The love of flowers is a consequence of modesty and an accommodation with disappointment. Some things need to go permanently wrong before we can start to admire the stem of a rose or the petals of a bluebell."

— Alain de Botton, *The Course of Love*

Falling into Winter

I was standing outside of my motel on the strip in Seattle, while my father was working. I was 13 and smoking a cigarette, when Scotty Pimpin first noticed me. I Even though I had been having sex, drinking and smoking weed already, I was actually very naive to the world of pimps and sex workers so had no idea why this much older and very attractive guy was taking such an interest in me?? But I quickly took the bait. I was a pretty quiet kid but loved to party and grew up school shopping at Kmart and thrift stores so when he came over and offered me weed and flashed all his fancy things, that was all it took. Next thing I know I'm packing a bag and sneaking off to run away with my Romeo. Take me out of this hell hole I believed I was in, was all I could think. It wasn't long before I realized that I would be falling much deeper than I could even imagine by getting into that van. I didn't understand why he had another woman with him either. I thought it was just him and I, so why was she here and why did she get the front seat? Turns out she was

his bottom girl. The one that would show and tell me all the mortifying things I would have to do, to make money for them, when we arrived at our destination in Oakland. "What did I get myself into" was all I could think. "How could I do these things they are telling me I would have to do?" Sure enough we pulled into some run down apartments where I was introduced, very vaguely, to his very intimidating family members, in the middle of the projects. Well at least I get to go shopping" my young mind told myself. We went shopping, but I didn't pick my clothes, he did. Short tight miniskirts and outfits I never in a million years would have picked out myself. That same day I was told not to make eye contact with any other black men, don't talk to other street workers and how to avoid cops. There I was standing on a corner on international Blvd. and it wasn't 5 minutes later that the first John pulled up. A middle aged white man that apparently liked very young girls. It was over quickly and I don't recall the exact amount or even many of the details. I was however, pretty amazed that I could make that much money for what seemed like not a lot of effort. Scotty and Nicole stayed close those first few days and would collect all the money I made every couple of dates. Some days he was really hard on me and would make me stay out there all day until I made a certain amount. Some days he would be really sweet and let me take the day off and go shopping and get my nails done, those were not often, of course. He would punish me if he thought I did something out of line by giving me ice baths and hitting my legs to avoid bruising and he would often make me give him oral sex against my will. I wanted to make him happy but I also despised him. A typical twisted trauma bonding relationship. His family were all pretty terrible to me too. They would bitch smack me and make me watch their kids and give them sexual favors too. When Scotty left town, probably to go get another girl, I was left with his family and I didn't have a "bond" with them and did not know when or if he was coming back, so I made a plan to run away again. A regular client of mine helped me and bought me a bus ticket and I came back home to my mom's in Spokane.

Obviously, the story doesn't end there. I came back to find my family in even more shambles than when I had left. That experience compounded

with early childhood sexual abuse and other trauma no young child should have to witness, I was desperate for further escape from myself. Insert meth. I fell hard and fast. I was in and out of programs and one in particular program had a pretty positive impact on me. After completing that, I was able to finish high school and had a baby boy my senior year, but still my deep wounds and rebellious spirit got the best of me once again. I fell even deeper and harder into meth and prostitution to support my addiction. When a voice in the wind called me home, through a series of eerie events, with nothing but the clothes on my back, I cried out to God "if you are real then something has to give". I just couldn't go on like that anymore. Some nights I even found myself sleeping on the streets or passing out in some fast food lobby, but I knew deep down in my soul that I was created for more. That I was created for greatness. All of a sudden everything started to become sharper, brighter and more clear even in the middle of this deep dark winter I was living in.

Spring

I had quite a few out of body experiences over that long and dark season. One in particular, I can recall hiding away under a big semi-truck while the cops searched for this reckless girl that had just ran out of a local department store with a pair of new shoes. It was as if I had no choice, my spirit was literally yelling at me to turn myself in, that it is what I needed to do. Next thing I know I'm being hogtied, traumatically beaten by the cops and taken into custody. I suppose something in me broke that night. I was so sick and tired of being sick and tired. It was time to die so new life could spring forth! Picking up the New Testament, in my jail cell and meeting some really sweet jailhouse ministers, ignited a flame in my soul and reminded me that life doesn't have to be like it has been. That God, thru Jesus, was giving me a chance to live right and walk into the greatness He had planned for me. I had a beautiful son that I thought about every day and my supportive mom that was able to care for him while I was out of my mind. I also had a diploma and managed

to keep all my teeth and my health even after all the abuse I put my body through. I had this new and fresh faith in Jesus, my savior and king! A kind of favor, I believe only God could have given me. I would not waste any more time on this destructive path. I would fight for true freedom. So I did. I got my son back, a real job, a beautiful church family and God blessed me with the most amazing husband. It's amazing the stark contrast between a life with God and one without Him. Someday I'll write a book about that! When the snow melts, the rain comes, giving water to the sower. That didn't mean that I didn't have any problems, I just wasn't the one necessarily causing them anymore.

Summer

Summertime has always been my comfort zone and I was happy there but also realizing every day that there was more to life then I was currently living. Complacency had set in and where there was once new life and fire in my soul it became dry and mundane. I began to realize something was missing and remembering that time that I was on fire for God and I was thirsty for more of that. I was also being nudged in my spirit to share my story. I had already shared my story of recovery from my life of drugs, even in front of my whole church at one point. I didn't understand what it meant until I began reading a book a dear friend had given me. It was called Walking Prey. It was about a 13-year-old girl targeted by an older man and forced into the sex industry. I couldn't believe what I was reading! Actually I could, because I had lived it! It was a part of my life that I had always kept hidden from most people. But that was clearly the part of my story that had yet to be fully redeemed. I suppose God thought I was finally able to face it and heal from that trauma that I carried a ton of guilt and shame for all those years. I think so often it takes those times of true rest in your soul to learn and reflect on why we are the way we are and that we can't even begin to imagine the greater plans God has for each of our lives. It was at that serendipitous time that it was clear God had majorly set me up to receive the healing that my soul so desperately needed. It was at a concert that God had clearly spoken to

me to attend, that Caleb Altmeyer got up and gave a small message at. It was about getting off the sidelines and getting in the game. That God is moving in big ways and wants us to step up and help the team out! Not only was the message spot on but he proceeded to talk about a safe house that they were opening for women being rescued from sex trafficking! And that's when I met HRC Ministries. They asked if I'd share my story and help mentor women that they help and serve. And so I vowed after that if I was ever asked to tell my story then I would. And so I did.

Falling for winter

"Without the bitterness of slavery, we would not know the sweetness of freedom. Without the blackness of the night sky, there would be no stars"

Connilyn Cosette.

I could never understand why there were so many people that would express that they were glad they went through hard seasons because it made them who they are today. Ha! "No way" I used to think, when I heard that Ludacris teacher. I thought for sure that I would change so much if I could go back in time. Well I'm officially converted to one of those "crazy" people. If sharing my story can help inspire the same freedom in just one person, it makes it all worth it. It has also made me realize my deep appreciation for life, love and peace really are the sum total of all the bad and good things in life. Since I've opened up about that traumatic time in my life I've gained more freedom and healing than ever before. It's given me the strength and courage to walk out my God given gifts with boldness; helping HRC open up our Thrift Store, consistent mentoring opportunities with the residents in their program and even opening up a local coffee shop that partners with nonprofits like HRC. God has done so much in the last few years and none of it could have happened without that long and dark winter. So instead of wishing it away, I'm allowing God to use it to grow his garden, his way and embracing all the seasons and learning that they are all necessary for life to flourish.

Tanya Herrera

I was born in Colorado. I moved to California for school. I went to a Bible college. After college, I wasn't ready to go back "home" to Colorado and ended up staying out here. I moved up to Marina Del Rey to become a live-in nanny. I ended up really liking the city and left my job as a nanny and found myself living on a credit card. In a vulnerable position with money, I ended up getting into a sex trafficking situation where the guy who I thought liked me, ended up becoming my pimp. Not knowing God for myself, I called out to him in hopes that if he was real, he would hear my cry and help me. Days later, I met two clients who came to me for service who ended up offering to help me escape the pimp. I escaped and I have been completely free of prostitution for 7 years. The last 7 years have been the "un-doing" of that life and the healing of my soul. I have now stepped into the first part of my purpose and that is to help people get out and get free of sex trafficking. I recently started selling candles so I could make money to help those trafficked get out for free. I was blessed by God with an investor and salary pay while working on the candles. I have entered my promised land. This is just the beginning.

CHAPTER 7

God Chose Me

By: Tanya Herrera

I had just graduated college. I wasn't prepared to go back home to Colorado and wanted to stay in California so I became a live-in nanny as I need both a job and place to live. I got the first job I interviewed for. It ended being this young couple who had a baby. They lived in a condo building that cost millions. I had just entered the other side of life. I went from a college dorm to a high-rise condo in one of the nicest part of LA.

After being a nanny for a few months, I left the nanny job because I wanted to work less and enjoy the city and my life. I left the nanny job, moved back home for 6 months, then moved back to LA. I don't remember having a job and I was living off a credit card. I was renting a room in a house and then decided I wanted to move.

I found some apartments and got in my car to go look at them. I got lost in a really bad part of town. It was really run down and not a good area and I had definitely never been in that side of town before.

I pulled over to a gas station to get directions (this was before GPS on the phone). I went in and stood in line to ask the gas station clerk for directions. I got tired of waiting in line and walked out. As I was walking out, this big tall guy came walking in. Without thinking, I asked him for directions. His response was, "I didn't come in here to give you directions." I didn't know what he meant by that but we ended up walking over to his car and talking.

He told me he was on his way to mechanic school and asked if I could join him that day. I told him "no" but that if he really wanted to hang out that he could follow me around to go look at apartments.

A the first (and only) apartment we saw, he kissed me. We didn't look at any more apartments and were headed to a motel. After that night, I ended up seeing him almost every day and most nights. We ended up liking each other- or so, I thought.

After we had been hanging out for almost a month, I shared with him that I was running low on money and I didn't know what to do. The first thing he said to me was, "what about a sugar daddy?" I didn't even know what that was! I had to ask him! He told me what it was and I said "No. I couldn't do that. That's not me," or something like that. Looking back, that was the same night he aggressively grabbed my arm. That was also the same night when he sat next to me on my bed and I felt evil. I don't know how I knew it was evil but I just did.

Days later, I gave him my last $1,000 as he said he could have someone "fix my credit" for me so I could get approved for a higher credit limit on my card. I never saw my credit get fixed or any mention of my credit being fixed again.

The next thing I remember; all my things were packed in my car. We started staying in motels together and he taught me how to post myself on Craigslist. I don't remember having or keeping any of the money.

Maybe 3 weeks in to living in motels, he started taking my car keys with him when he left. I think he sensed that I wasn't liking how things were going and he was scared I was going to run off.

One night when he wasn't there, I remember lying on the motel floor between two beds. I was crying and sobbing. I was crying out to god...if he was real... if he could hear me... would he help me? I needed help and I was crying out to God truly wondering that if he was out there and could hear me...would and could he help me?"

Days later, I had two men come see me from Craigslist. Both of them ended up talking to me and telling me that if I ever needed help "out," they could help me. One of the guys in particular, said I looked

like I didn't belong in the situation. He could tell something was wrong. It was this guy that I ended up calling to help me get away.

I knew I had to make a plan that would both get me my car keys and have him leave the motel at the same time. So, I asked him if I could go to the store for a few things. He said "yes" and gave me my keys. I left and called him about five minutes later and told him that I got a flat tire. He believed me and left to go "help me." As soon as he left the motel parking lot, I ran up there as fast as I could and grabbed my laptop and whatever else I could. I got in my car and followed the guy who was helping me and we drove to a different area of town. I still had no permanent place to go and no job.

I met another guy who was trying to help me. He ended up going through my phone to get my parents number so he could call them and tell them that I was in "trouble" and "needed help." The day after he called my mom, I woke up to knocking on the door. It was my family who came to get me and take me home.

This is the story of how I escaped prostitution the first time. There were two other times I got back into prostitution before I was out…and out for good.

The two times that I ended up back in prostitution involved situations where I found myself needing a good amount of money fast. In one instance, my boss was "mentoring" me where being intimate with him was "part of the mentorship." I put in my two-week's notice and my plan was to look for another job. But in response, he told me that I didn't need to finish the two weeks and I didn't need to come back. There I was again, needing money and a place to live but having no job. My mind instantly panicked and before I knew it, I had re-entered the world of prostitution through sugar daddies…and was once again back where I was before.

The last time I tried to get out was a bit different. It's too long of a story to tell as it's a story in itself.

The longer story and real story is how I stayed out of prostitution. It's been 7 years of a series of situations, experiences, jobs and time itself that has helped me, taught me, and showed me how to stay out.

The last 7 years have also been about the healing of my soul through things that I didn›t want to do but knew were good for me. It was as if slowly but surely, that old life was being chipped away. But I really can›t talk about the last 7 years of my life without talking about God. I'm hesitant to talk about this because the God I know and met, is nothing like the God I heard and hear about today. To write about what the last 7 years of my life would take me so long and I could go in countless directions on the things I learned and what those years did for me and how each and every battle I encountered impacted every area of my life and challenged my old behavior and thought patterns. But for now, I will just say that I did not do the last 7 years of my life alone. There was no way I would have made it. There is no way I would have chosen the path I was lead on. Absolutely no way! I'm not wise enough. I'm not strong enough. I am definitely not humble enough to have done the way it played out. God was leading me. Guiding me. He was with me every step, every day. He was there every-time I cursed at him because I didn't understand and I was in pain. He was there every-time I yelled at him because I didn't like his plan. Just when I was so tired and weary of the battle and didn't want to go on anymore... he sent me Cassandra. She's the person God chose to bless me with to make stepping into my purpose possible. What happened with that, is another story. The story goes on. This is just the beginning.

Karyn Darnell

Dr. Karyn Darnell, Author, Visionary, Healer: Creator of the "True Privilege," book series which is an epic adventure surrounding the dark underbelly of human trafficking. My whole goal in writing this series is to bring attention and solutions to the plight of sex and labor trafficking globally. I will soon start the second series of the "True Privilege," saga comprising another three books of thrilling adventure. In this next series, I will highlight the continued carnage of human trafficking, dating back to World War 1 and 2. It should be another hair raising, fascinating journey, keeping the readers on the edge of their seats with nail biting suspense. The books are fictional, faith based stories, involving a family line of abolitionists, spanning over a hundred year period. The motivating and intriguing story lines were written with the hope of inspiring others to complete their purpose in life and help those who are dis-empowered globally.

Life's Vision: I'm a mentor to leaders and storyteller who impacts nations for the sake of high risk people and children globally.

CHAPTER 8

Saving Lives and Building Communities

By: Dr. Karyn Darnell

My name is Dr. Karyn Darnell, I have a DOC, Doctorate of Christian Counseling. Over the years, I have worked with many who have been sexually violated. **Every 68 seconds an American is sexually assaulted. Most sexual violence victims are age 12 – 17 years old.**[1]

My aim is to educate youth globally to recognize predatory practices. Such as grooming techniques, fantasy relationships, and the difference between healthy and toxic relationships. **Prevention** is key when dealing with the deadly trades of sex and labor trafficking. **Why?** Because once a person falls prey to slave masters, very few make it out alive. My goal is to create student education and awareness curriculum, create rescue teams and establish rehabilitation services.

How effective is any nation in recognizing and combating trafficking?

The numbers are dismal for rescue and rehabilitation facilities. So, I believe education and community awareness is key in preventing youth from falling prey to predators. Especially on social media sites, chat rooms and dating apps.

- In America, 18,000 students a day send a naked photos.
- 9000 kids a day are sextorted – meaning their predator will demand more naked photos and videos of sex acts. They are blackmailed into the trades before, during (at lunch) and after school. Most will still live with their parents when trafficked.
- 58% meet up with their predator to negotiate the photo/video back.
- Approximately, 78% of those working the sex trades were previously violated. A large percentage of those in the sex trades were provided for by the welfare system.
- Poverty fuels the sex industry with vulnerable youth trying to survive.[2]

I have been a Registered Nurse for years. As a healthcare professional, I realized if sex trafficking was allowed to thrive, it would create a devastating health crisis. It's a vicious cycle of abuse, torture, sexually transmitted disease, unwanted pregnancies, abortions, and infections. Not to mention the mental health crisis of broken individuals and families. Post-Traumatic Stress Disorder, Bi-Polar Depression, Suicidal Ideation, and anxiety disorders are prevalent among survivors. Only about .04% of cases internationally are identified.

Millions in human trafficking remain nameless and faceless disposable people.[3]

Who are they? Where do they come from?

Statistically, they come from poverty, cycles of addiction and prior victimization through molestation, rape and fragile family systems. **Once on the market a person generally lasts up to 7 years.**

Then what? Extermination of a young life.

I have been in Christian ministry in some capacity for years. From working church ministries, International Healing Rooms, prison min-

istry, Christian counseling and global missions in Mexico, Europe and China.

I worked as a chaplain volunteer for Santa Rita jail, conducting services and counseling the women. Most were in jail due to drug charges, domestic violence, addiction and prostitution. A large percentage had histories of childhood molestation, rape, or sex slavery. Many were brought up in the child welfare system or a product of the foster care system which has many sexually violated survivors.

What's the fastest way to emotionally assonate someone? **Repeatedly, rape them, especially before age eighteen.**

When attending Pentecostal Theological Seminary. I met a professor who was a Chinese national. He was miraculously saved in China and was a major evangelist in the underground church. I was invited to work with the underground church. I was told about severe trafficking happening there as well.

Most hotels in China set aside whole floors for prostitution. Many times, the men requested, mothers and daughters to work together for paid sex. My heart dropped realizing girls were being sold by their mothers. The question is: Were both mother and daughter sex slaves with no control over their decisions?

My most recent mission was to Hollywood, California from 2013 – 2020. I was called by God to minister in what many consider the "Artistic Capital of the World." One of my assignments from the Lord was to "Prayer Walk," the beaches of Marina Del Rey, Santa Monica, and Malibu.

I prayed for a great awakening to hit America and go around the world. I prayed God would clean up the TV/Film industry as the content was becoming more violent and sexually perverted. I prayed God would expose the darkness in Hollywood. I walked the beaches for five years and began having open visions. I saw huge gatherings on the beaches. People were being baptized in mass numbers. From the west to the east, I saw

revival and awakening would come despite all the social unrest. When I left in July of 2020, Evangelist Sean Feucht, was holding mass

meetings on the beaches of Southern California. Many were baptized in the ocean and rededicated their lives to Christ. Then from the west he moved east during the Covid 19 pandemic holding huge worship meetings.

During my time in Los Angeles, I never discriminated against who God asked me to help. I met young struggling starlets, hoping for that big break in the industry, and many times helped pay their bills. I met some people affiliated with the biggest names in the music industry and film. It was always the same, fame comes, and fame goes. And for most, fame never comes at all. The world moves on, leaving the spotlight and money behind.

Everyone was different, some were transgender, straight, or bi-sexual but there was always one guarantee. No one was immune to the struggles, heartbreaks and disappointments in life. We all struggle, not one of us can escape the issues of life with all its joy and struggle. Whether it's a toxic relationship, financial problems, mental health issues, suicidal ideation, addiction, or victimization.

Most I met were mad at God, themselves or others. It's a typical response when life doesn't turn out the way we dreamed. What I did note was, many were violated sexually in some way. Either trafficked by parents, raped by associates or sold their bodies and souls trying to make it to the top.

Prayer is always key to bringing the breakthrough. Often, I would join Christians at the International House of Prayer. We began praying there in 2016 – 2019 until the Covid 19 pandemic hit. It was located on Sunset Boulevard in between the Rainbow Bar and Grill and the Whiskey A Go Go bars. Prophet Meri Crouley was faithful in leading the prayer each week and invited special guests. The whole motive was to see Hollywood transformed into Holy-wood.

Special prayer went up to expose the dark secrets of the industry. Most importantly, the pedophilia and 'Casting Couch,' that hurt so many. After some time, there was significant breakthrough as listed:

- **Bill Cosby:** He was accused of sexual assault allegations which became highly publicized during the "Me Too" Movement. Cosby was imprisoned until the conviction was vacated in 2021 by the Supreme Court of Pennsylvania, due to violations regarding the 5th Amendment and the 14th Amendment due process rights.[4]
- **Corey Feldman:** Came out in 2016, revealing his molestations as a child actor,[4]

Wikipedia, Bill Cosby.

along with best friend and fellow childhood actor, Corey Haims. Haims claimed he was brutally raped by a senior actor while shooting a movie at 13 years old.[5][6][7]

- **Matt Lauer:** Terminated from NBC in November of 2017, after a detailed complaint of inappropriate workplace behavior.[8] Wikipedia, Matt Lauer, allegations of inappropriate sexual behavior.
- **Harvey Weinstein:** Sexual allegations October 2017. Arrested May 2018 on rape charges. He is serving a twenty-three-year prison term for rape.
- **Weinstein Effect:** The allegations against Harvey Weinstein, caused global domino effects exposing molest, rapes and misconduct by famous or powerful men.[9]
- **The "Me Too" Movement:** Hit in reaction to the sexual abuse allegations against Harvey Weinstein in early October 2017. Giving voice to many who were sexually violated in Hollywood.[10]
- **262 Celebrities, politicians, CEO's and** others accused of alleged sexual misconduct around the world.[11]
- **NXIVM:** considered an American cult that recruited victims for sex trafficking was exposed. In early 2018 NXIVM's founder, Keith Raniere, and actress Allison Mack, were indicted on federal charges which involved sex trafficking. The cult included sex trafficking, forced labor, and branding its slaves.[12]

- **Hugh Hefner's Death and Mansion:** Hugh Hefner's mansion was only a few miles from the International House of Prayer. One night after prayer, the Lord directed me to go to the Playboy Mansion. It was only a few miles from the House of Prayer. I found the address on my GPS and drove in front of the mansion. I prayed for Hugh Hefner who was on his deathbed. He passed, September 27, 2017. The mansion was old and dilapidated when Hefner died. After his death, looters stripped the mansion bare. "The bedrooms, even Hef's - were stripped of things like sex toys, gold-plated statues, used sheets and lingerie," a source told US Magazine Globe.[13] The mansion is being restored by the new owner.[14]
- **Jeffrey Epstein:** Arrested on sex trafficking underage girls July 2019. Died in jail August 10, 2019.[15]
- **Ghislaine Maxwell:** Close associate of Jeffrey Epstein, was arrested in 2020, charged by the US federal government with crimes of sex trafficking underage girls. The US Virgin Islands Department of Justice on July 10, 2020, states Maxwell was also under investigation in the Caribbean.[16]

President Donald Trump prioritized the war against human trafficking. January 2020, He recognized the 20th Anniversary of the Trafficking Victims Protection Act. He signed an Executive Order Combating Human Trafficking and online Child Exploitation in the United States. The President signed nine pieces of bipartisan legislation to fight human trafficking, domestically and globally. President Trump developed a National Action Plan to Combat Human Trafficking and it was built on the Trafficking Victims Protection Act of 2000, that focuses on three pillars, Prevention, Protection, and Prosecution.[17]

We prayed for over 4 years at the International House of Prayer on Sunset Boulevard, in West Hollywood. Many high-powered people were exposed at this time and beyond. It's in the news daily. I'm sure many were praying for Hollywood to be cleaned up too. Prayer is powerful and the breakthroughs were tangible.

Statistics: The number of sex and labor slaves is lucid. It's estimated there are 20 - 40 million slaves globally. The United Nations refers to it as the "Hidden figure of crime." These numbers include forced labor and sexual exploitation. Many are forced into the sex trades in exchange for drugs, protection from gangs, shelter, food, and daily necessities. It's called 'Survival Sex.'

The average age a teen enters sex trafficking in the US is between the age of 12-14 years old.

What is sex and labor trafficking? A short, non-exhaustive definition is as follows:

- The soliciting of anyone for a commercial sex act or forced labor.
- The recruitment and harboring of someone with the sole purpose of merchandising sex or using them for free labor.

Sex and Labor Trafficking Tactics:

Fraud: False promises of wages, a dream come true, or pretending to be a significant other.

Force: Use of violence personally or to family members, torture, sexual assault, forced addiction from substances, burning, and restraint.

Coercion: Threats of harm, threats of reporting to authorities, quotas, creating dependency, debt bondage, or confiscation of property or possessions.

True Privilege Book Series:

I am writing a fictional series of books to help people recognize the tactics of trafficking. I began receiving visions after Christmas in 2005. I had no intention of becoming an author and wasn't aware of the enormous numbers of slaves globally.

I received the first vision of a young couple interacting. I tried to write what I was seeing, and it was lousy. I turned off the computer and talking to God said, "I'm not a writer and I don't know anyone in Hollywood." My mind immediately saw the books and movie series. This was the beginning of the fictional series "True Privilege," which will comprise 9 books all together.

The books cover a hundred-year period about a family of abolitionists. Favor Wisedor, the most eligible bachelor in town and his maid Purity are the main protagonists. In the first book, "The Unholy Realm," dark powers and predators are revealed who prey on the young and innocent in Bristol, Rhode Island. The story is faith based, allowing the

reader to see into the unseen spirit world. The emphasis throughout, will focus on the sex trades, grooming tools, toxic relationships, and predatory practices of enticement. My hope is to teach youth to avoid the tragic world of sex trafficking by recognizing deception and foul practices.

As the story progresses, the main protagonist, Purity is swept into the underbelly of sex trafficking while working a night job at Mave's of Bristol. Things grow perilous and Purity is transported to the New Earth located in the universe by Light beings. She encounters the Captain of the Lord's Army and is called to, "Set the Captives Free." It's a wild story of intrigue and imagination.

Original songs are introduced that will captivate the reader and emphasize the target themes. Just a few of the song titles and themes are explained below.

- **Freedom Cries:** Rachel a mail order bride, is sold as a sex slave her first day in America. The song shares the sorrow of losing true freedom when a person is sold and used as a sex and labor slave. The question is: Where are those to set the captives free?
- **Impressions:** Mrs. Wisedor sings 'Impressions.' She is a self-centered aristocrat who only cares about keeping the family's wealth above all else. This song will resonate in hearts around the world who are perpetrators of wealthy impressions over genuinely caring about others.

- **Change:** Purity is so discouraged about her life that it is going nowhere fast. All her dreams seem further away with each passing day. The song, 'Change' will appeal to millions around the world who are desiring to leave a legacy.
- **True Privilege:** This song is sung by Purity who spells out what 'True Privilege' looks like in this world, not just serving ourselves but others.
- **Spirit Move Me:** Purity is desperate for opportunity and to fulfill her dreams. She is depending on the Holy Spirit to accomplish all she's called to do.
- **Invisible Girl:** Purity is serving at another Shadow Brook Estate Gala. It is torture to see Favor the man she loves, surrounded by crafty young, gorgeous socialites. She feels 'invisible,' and overlooked, not 'good enough,' like so many around the world.
- **Girl in the Mirror:** After Papa's death, to make ends meet, Purity starts to dance with strange men at Mave's of Bristol. In the dressing room, all dolled up, she sings 'Girl in the Mirror' not quite recognizing her new image or trusting her decision. Many around the world can totally relate to regretful decisions that plunge them into a world of disaster.

My goal is, **"Saving Lives and Building Communities."** The books will be available on Amazon.

Notes

[1] Department of Justice, Office of Justice Programs, Bureau of Justice Statistics. National Crime Victimization Survey, 2019 (2020)

[2] Million Kids website. Opal Singleton founder.

[3] "What is Human Trafficking," Californians Against Sexual Exploitation. www.caseact.org/learn/humantrafficking.

[5] The Hollywood Reporter, Corey Feldman on Elijah Wood Hollywood Pedophilia Controversy: "I Would Love to Name Names." May 25, 2016.

[6] Entertainment, Corey Feldman accuses Charlie Sheen of sexually abusing Corey Haim in My Truth Documentary. March 10, 2020, Rosy Codero.

[7] Los Angeles Times,

[9] Wikipedia, Harvey Weinstein.

[10] Wikipedia, "Me Too," Movement, following the exposure of the widespread sexual-abuse allegations against Harvey Weinstein in early October 2017. The movement began to spread virally as a hashtag on social media. Widespread media coverage and discussion in Hollywood, led to high profile terminations from positions held, as well as criticism and backlash.

[11] Vox, 262 Celebrities, politicians, CEO's and others who have been accused of sexual misconduct since April 2017.

[12] Wikipedia, NXIVM, an American cult that engaged in sex trafficking, forced labor and racketeering. The company was a recruiting platform for a secret society, "DOS" in which women were branded and forced into sexual slavery.

[13] News.com.au, Hugh Hefner, Playboy Mansion now rotting and derelict after Hugh Hefner's death.

[14] www.the-sun.com Massive renovations are underway at the former Playboy mansion that once housed the late Hugh Hefner and his "bunnies."

[15] Wikipedia, Jeffrey Epstein, Life and sex trafficking and death.

[16] Wikipedia, Ghislaine Maxwell, Arrest on sex trafficking.

[17] Fact Sheets, Law and Justice, The Trump Administration Is Committed to Combating Human Trafficking and Protecting The Innocent. October 20, 2020.

Kelly Patterson

Having survived the nearly un-survivable life of sex trafficking, Kelly Patterson's skills come forth in maneuvering through the difficult arena of this very painful subject matter. It is Kelly's belief that facing the truth with peace is not only possible but is something she has experiential knowledge of. Her courage to walk into a crowd and discuss the controversial is a communication gift that she excels in. Her artwork and writing skills in her autobiography "From Trafficked to Treasured" reflect her passion to reach out to other survivors, lend understanding to their family and friends, and light a fire in others to help in the fight against sex trafficking. Her passion and love of others is evident in her daily sacrifices of time and energy for the benefit of others. Kelly is a tireless advocate for the downtrodden and misunderstood. Her heart is to see others find God in the journey through pain and to walk alongside the hurting. As a female Pastor, she is a tireless advocate of Biblical equality for male and female. She does not bend to anything that opposes her belief in a sovereign God. With confident character, Kelly shares the many experiences of supernatural interventions and encounters with a relational God. Her knowledge of the deeper matters of the Word of God is evident in her teaching style, using both Biblical depth and yet a relatable style is a unique calling which she readily shares with others. Kelly values honesty and integrity in others and expects nothing less from herself. Kelly is a wife, mother, and grandmother. She is the Founder and Executive Director of Treasured Lives, a 501c3 anti-trafficking non-profit, a speaker, consultant, and an active advocate in freeing those wounded from the effects of sexual crimes such as abuse, assault, and trafficking.

kvp777@hotmail.com

CHAPTER 9

From Prostituted To Pastor

By: Kelly Patterson

Exodus 21:16 NIV

"Anyone who kidnaps someone is to be put to death, whether the victim has been sold or is still in the kidnapper's possession."

Nothing prepares the ears to hear the horrific details of sex trafficking of children. It is that unspeakable thing. The hearing of it is worse than fingernails on a chalkboard, more perverse than pornography, and uglier than a beheading. Thus the willingness of one to listen further takes a courageous soul and an individual's

heart knit to the Heavenly Father's heart. Only then, can an ear listen fuller, endure the heartbreaking truth, feel the depth of pain that must be fellowshipped with, and allow for the acceptance of the reality of its prevalence in our world.

My story is that story. I write this with the knowledge that it will summon emotions and that it may cause more questions than it will answer. And yet, the Truth must be told again and again. Each time it is shared, it carries with it pain.

Undeniably, sex trafficking is an uncomfortable subject. Telling my story is never easy. However, it has merit and prayerfully will produce fruit. Therefore, let us begin at the early age of six years old, where my first full memory of being introduced to a trafficking ring began. I was groomed by someone close to our family. The groomer had specifically

targeted me. He was well known and admired in our community and state. Hidden beneath his philanthropic exterior was a sinister man. On this particular day he brought me into a room with men sitting in a circle. Each one passed me around molesting me.

Upon ending their horrific first act of me being "trained" for trafficking, the men ensured my silence perfectly by stating three things.

First, I was told that they knew where my parents lived and that they could easily blow up our propane tank and kill us all. Secondly, they reminded me that I had a younger sister and if I did not comply, they would take her. The final icing on this piece of dung cake was saying "we can't help ourselves, you're too sexy". Too sexy? A six-year-old child is not sexy. Can you see what they did? They offered terrifying threats and then to seal my shame—they put the onus of their crime upon me. After all, they were the adults in the room and I was the child. Therefore, the message was received, this was my fault. This. What was this? It felt awful. But what was THIS?

In our small community, children of all ages were allowed to hang out with friends after school which concluded around 3:00 pm. Most of the children in our community were not expected to return home until the dinner siren sounded at 6:00 pm. People did not lock their doors nor worry about their children hanging

out with neighbors. After all, we were in the Heartland, the Midwest—a place known for its safety and integrity. This sense of safety and lack of helicopter parenting is still alive and well in many small rural communities today.

My parents were completely unaware of what was happening to me. Most days I played with friends from 3:00 until the siren rang. I went home as did all the other neighborhood children for dinner. Unfortunately, there were also many days when a man signaled me from the perimeter of the school yard to come to the building where another type of "school" would resume. Part of that "schooling" was how to appear normal, how to shut off and how to keep the secrets. I was a victim of ring trafficking. When they were done with their savagery, the 6:00 pm siren would sound and I would walk out the door with their words

echoing in my ears "remember to forget"; and walk down the street into a fog of forgetfulness.

Unknown to the average person and still happening today, there are individuals lurking among small communities and rural settings with an agenda. This agenda is to financially profit off of the lives of human slaves. They are found in large cities as well as across the world. Ring trafficking is run by organized crime and is thriving in our political, entertainment, and business worlds without much effort.

After 6 years of showing up when summoned, at the age of twelve, I thought I would exercise my right to say "no" and did not show up for them where and when I was supposed to. This resulted in being horrifically gang raped. That was my punishment. The trauma from gang rape is so horrific that you are changed in an instant. Nothing in your world is the same. I soon began to withdraw from close ties to my family, to run with rougher crowds, and began experimenting heavily with alcohol. Unfortunately, this appeared to be nothing more than

teenage rebellion. The rebellion road is rarely taken as part of a child's natural journey without a painful reason behind it. That does not mean every child in rebellion is being trafficked, but it is worth finding out WHY they are rebelling. Once ring traffickers have you, it is very difficult to escape. Their tactics are nothing less than trauma based mind control. When you take away every form of safety that a child has and replace that with the constant reminders that they are watching you while forcing you to periodically watch the torture of others; all avenues of feeling protected are removed.

My family moved many times in and out of our home state due to my father's job with the Government. Within a short time of being in a new community, that local trafficking ring would connect with me. Even when moving to states far from our Midwest home, I would be summoned by name from strangers. It seemed they owned everything and nearly everyone. There was nowhere to hide. Many nights I would stand in the shower with shampoo and water running down my face while I cried profusely. The helplessness was overwhelming.

My teenage years were difficult for even me to understand. My parents were unable to control much of my behavior and were bewildered as to my pulling away from them. At age seventeen I was kicked out of the family home and moved into an apartment. This was what the ring had been waiting for all these years. Ring traffickers are incredibly patient; they are poised and ready to pounce upon emancipation. They have been raising a "product" for their purposes and when that "product" reaches maturity, they begin to utilize it. In this case, that product was me. Prior to this age, the traffickers stand by while someone else (often parents or other family members) feeds and clothes their "product". The ring has put very little investment into raising this child, all the while anticipating a

huge profit margin. Now they have you. You are well trained and can be used in any field they have been grooming you for. While living in your family home, the traffickers work hard to leave no visible marks on you. Keeping their anonymity is vital to the continuation of their operations.

I was utilized in virtually every form of commercial sexual exploitation from that point on, including: exotic dance/strip clubs, escort services/prostitution, pornography films, and elite parties. They flew me in and out of the country— where I entertained famous people, heads of nations, judges, businessmen, law enforcement, and highly esteemed political figures. I have since learned from special ops that my trafficker at this age was the head of very specific ring trafficking over the United States, a terrifying reality and yet it explains so much.

There is nothing glamorous about that life, not when put into the context of why you are there. They (the handlers) never let you forget that you are less than human, that you are merely a product. In public, you may be treated like the center of attention or the star in the room, however, what happens in the shadows is untold misery and inhumane. Traffickers and handlers torture victims in hideous ways all the while demeaning you.

Additionally, they drug you out of your mind and destroy your body repeatedly. They also prefer to see a victim addicted to drugs because that keeps their "product" attached to them and in trouble with Law

Enforcement. Most, if not all traffickers have vile skill sets that would astound even the worldliest thinker. Escaping was an ongoing dream, the never-ending place my mind would travel to.

I tried many escapes and some of the escapes included attempting to bring another victim with me. On one occasion I got my hands on a pistol, came up with a plan to help a bunch of us escape, and nearly succeeded. We were being kept in a bus for the weekend and one of the handlers had left a pistol lying around. I grabbed it while they were partying and nobody noticed. I shared my plan with the girls and we began to walk it out. Unfortunately, we had Judas in our midst.

When I pointed the pistol in the face of the trafficker in the driver's seat and pulled the trigger, it just clicked. No wonder he did not show any fear when I held up the gun. A new girl had exposed our plan of escape and they had taken the bullets out of the pistol where we had hidden it in the bus. You can imagine that the punishment for this was hideous and I nearly died that day.

I was the thorn in their flesh as I was never satisfied to continuously "take it" without causing them trouble. If I kept this up, the time would come when they would not put up with it anymore; at least that is what I was told. Eventually, I nearly lost the will to continue the battle for freedom due to the inevitable torture whenever I failed. But maybe, just one more time....

And that is all it took—ONE MORE TIME! A very long story made short, I survived. At nearly the age of twenty-two years old, someone looked in my eyes and let me know that they saw a person. That was all I needed, that one piece of hope that maybe I was salvageable, maybe I was worthwhile. The look of caring spoke to my heart to run and I did. This time I succeeded.

"While it was years ago, it was only yesterday for me" – these are the first lines of a poem I helped write. There are no deader words spoken to another than being told to "just put it behind you". For someone who has suffered unspeakable trauma and torture, simply putting it behind you is unhealthy. In fact, once the full ugliness of one's past is faced, there is no putting it behind you. It is a beckoning call to march forward

through terrain that the strongest of characters would prefer to pass by. Trudging forward is a choice. You can be assured that it is a choice that will lead to greater healing, greater courage, greater strength, greater ministry, and brighter days. Why? Because we are called to wage war.

The Christian life IS war and we are to stand in the battle (Ephesians 6). Living in the land of denial is also a choice. I learned it young and I learned it well. I put things so far behind me that I buried many of the atrocities in my subconscious. When it would rear its ugly head, I would tuck it under, drug it under, drink it under – because I could not and would not face it. If you choose to bury things, sadly you bury most things; even good things. Then where is the ability to see God's recompense? If left buried, you will miss living out Romans 8:28 NIV "And we know that in all things God works for the good of those who love Him, who have been called according to His purpose." Even the worst of things are promised to work to our good and I can attest to the truth of that. I have the privilege of working with survivors of sex trafficking. My favorite Biblical character is Joseph and my favorite verse in the Bible is Genesis 50:20 NIV "You intended to harm me, but God intended it for good to accomplish what is now being done, the saving of many lives."

Until the first flashbacks of my past began to break through, I had hundreds of partial memories like puzzle pieces without a finished picture to identify with. I had multiple broken bones which had long since healed that I could not explain.

There were physical scars that I had made up stories to answer for because not remembering their origin brought me shame. While I walked in shame, there was nothing concrete for me to fully connect its intensity to. Shame was a huge looming shadow that followed me night and day. There was no escaping it and yet I could not find its reason for being. How could I heal?

Inevitably the day comes to all who desire spiritual growth, the day of facing your own past. Facing your past does not diminish the fact that the blood of Christ fully paid for our sins and the sins of others. Recognizing suffering as persecution is a freeing truth; and persecution is nothing to be ashamed of. As believers, we are promised persecution.

2 Timothy 3:12 NIV says

"In fact, everyone who wants to live a godly life in Christ Jesus will be persecuted."

WILL BE. There is no "might be" or "maybe" in that passage of scripture.

For the record, I do not believe the Lord sent me into the trafficking world. I believe evil people did what evil people do. And it is God Who provided a way to escape; but more than that, God provided me comfort, teachers, His rhema (personalized) word, and compassionate relationships for the healing journey. There are few who are persecuted more than sex trafficking victims. Suffering of such magnitude has never been at a rate this high in all of humanity's history. The United Nations recognizes 48 common forms of torture used in sex trafficking. This should cause all to pause, to weep, and to pray.

It is my deepest hope that God's children will work together to stop this atrocity which takes the lives of 99% of its victims! That death toll is outrageous and should capture the heart of every believer. Is God calling you to this battle? If the answer is yes, you an contact any of the authors contained within this book. I have been a Lead Pastor for 17 years now! And ohhhh there is so much more to this story...

Leslie Mahre

Leslie Mahre is an itinerant minister and prophetic intercessor and is currently serving as Prayer Coordinator for Women Fighting Trafficking. Born and raised in Minnesota, Leslie graduated Magna Cum Laude from Bethel University in St. Paul, MN. Making her home in the Minneapolis area, Leslie raised two wonderful sons as a working mom for 26 years in the advertising and marketing field.

God placed the cause of human trafficking on Leslie's heart in 2010 after she found herself suddenly released from what had been a highly successful 20-year career with CBS Radio. She sensed God's hand was allowing her to be let go because he knew she would never quit no matter how challenging the job had become.

Leslie spent the next 4 years getting all in with God, practicing listening for the voice of God and devoting herself to prayer and serving others and those in her local church. During this time God began to give Leslie a creative vision for a media strategy tied to the cause of anti-trafficking and after much prayer and confirmation she felt the Lord lead her to sell everything, pack up her car and move to California in 2014.

The Lord has been ordering Leslie's steps in California and divinely connecting her in the body of Christ. She is a member of Harvest Rock Church in Pasadena and has served in several prayer ministries there, as well as at Pasadena House of Prayer, and Radiance House of Prayer in Hollywood.

Leslie believes that any great move of God always begins on our knees, or as one of her favorite prayer hero's, Lou Engle likes to say; "history belongs to the intercessors."

Lmahre@yahoo.com

CHAPTER 10

Victory!

By: Leslie Mahre

This is the first day of the Jewish New Year - 5782! Shana Tova! Happy New Year! Today is 9-7-2021!

As I prepared to write this chapter today I woke up and looked at my clock and it was 7:17 and I felt the Lord so sweetly speaking to me of completion and fullness and victory! You see, I began to hear the Lord speaking to me through the clock several years ago. I would see 1:11 and hear, "I'm lining things up" and get scriptures like

Deuteronomy 1:11

> *"May the Lord, the God of your ancestors, make you 1,000 times as many as you are and bless you as He has promised you."*

I would see 10:10, 11:11, 12:12, 2:22, 3:33, 4:44 (love that one as it reminds me to declare Isaiah 44:3-5 over my family), 5:55 (5 is the number of grace and I heard "triple favor triple grace that's the way we run the race!"), and on and on!

Back in 2017, while living in Pasadena right across from my church, I would wake up to go to 6 am prayer and get home in time to prepare breakfast for my six international students that I was the house manager over. Morning after morning I would glance at the clock and it would be 7:17! So I began to inquire as to what God was speaking through this odd time. This is not numerology by any means, but different numbers

hold different prophetic meanings and the number 7 represents perfection and completion of a cycle (think "God rested on the 7th day"), and 17 is the number for victory! So I felt God wanting me to begin to learn to declare the end from the beginning like he does and declare the victory is already won by the blood of Jesus and to see the completion of a thing as being done even before we begin. So I went deeper and asked the Lord if there was a scripture tied to this time and he gave me Revelation 7:17, (NIV). "For the Lamb in the center of the throne will be their shepherd; 'he will lead them to springs of living water. And God will wipe away every tear from their eyes."

I had just listened to Rabbi Jason Sobel from Fusion ministry in Hollywood give his Rosh Hashanah, head of the year message last night about the Hebraic year ahead and what it represents biblically and it was encapsulated in one Hebrew word; Shalom, meaning completeness and wholeness in every area of life!

Now fully inspired to begin to write my chapter, I sat down on the porch with my coffee for some Jesus time, and my bible literally fell right open to the book of Nehemiah. This was just providential to me because this is the very book in the bible the Lord gave me back when I was living in Minnesota and asking God how he could use my media and marketing skills to help build his kingdom and rescue children from trafficking. He showed me Nehemiah as a template for kingdom building, and how by co-laboring together with their families and their neighborhoods they could work as one to rebuild structures that had been broken down. He showed that when you come together with a mind to work and with a common God inspired purpose and vision, building with one hand and warring and praying down the opposition with the other, that you can accomplish in record time under the anointing and leadership of the Holy Spirit what it would take years to do in your own natural ability. Just 52 days was the time it took them to rebuild the wall.

So it's no coincidence that my bible fell open to Nehemiah today and it's also no coincidence that my church; Harvest Rock just happens to be doing a 21 day fast, 9/1-21 with daily scripture and prayer focusing on Nehemiah as we rise up and rebuild in our church and our nation.

I notice throughout my journey of faith that the Holy Spirit has these recurring themes, because he wants us to be one, and so he begins to work these threads of his themes in and through his words and our circumstances in ways we can identify it is him speaking to knit us together as one over the truth of his written word.

Then I was reminded on this 7th day, after waking at 7;17, that it was 7 years ago this very season of Rosh Hashanah that I set out to California with everything I owned packed in my car and not even exactly sure where God was leading or what I would be doing when I got there. But God had placed a big dream in my heart that involves building a foundation that will help support all of the ministries that are working to end human trafficking one life at a time. It involves a creative new idea on the internet which has not yet come to life, but I've carried in my heart and mind all these years.

So when Meri Crouley asked me if I would like to write a chapter in her new book my immediate response was a definite "no!" "I haven't done anything yet!"

But I hadn't asked God if he wanted me to. So a few days later I was in my bathroom putting on makeup and praying over the newly formed "Women Fighting Trafficking" organization, when I sensed the Holy Spirit speaking to me. He was reminding me that I didn't ask him about writing the chapter and gently convincing me that he has been doing something through me these past 7 years that wasn't about me but was about him and how he builds his kingdom on earth as it is in heaven.

Just as Jesus did nothing unless he first inquired of and heard from the Father, in the same way we as the children of God who are led by his Spirit are to listen to him and seek his plans and ways of getting things done. So I had to quickly repent of belittling in my own mind all of the amazing things he has done in and through my life these past 7 years and how he has divinely connected me and blessed me in and through his very body and his family here. He also reminded me that so many people view prayer as a last resort we use when all of our own plans fail, or even when we may have prayed but asking him to bless our plans and timing that were not of him. Matthew 6:33 (NIV) says; "But seek first

His kingdom and his righteousness, and all these things will be given to you as well."

God reminded me that what he has been doing with me here in California is similar to how Nehemiah started out. I didn't know what I didn't know about Cali and I had to scout out the land and begin to assess the damage and see where the gaps were and where the walls were broken down. He did it under cover when no one knew what God was about to do in and through him. He also told no one of what he was planning to do until it was time to begin the work.

So I've lost track of how many places I've moved and lived since I came out here and began this somewhat nomadic seemingly random lifestyle by the world's measures, and everywhere I've lived I've set up an altar of prayer and prayer walked the land.

My first stop led me to Hollywood when it would have honestly been my last choice and I would have never guessed that's where I would end up, but God knew exactly the path he had charted for me.

Before I had left MN I had taken a part time job with Macy's selling cosmetics for Clinique. As I sensed the Lord leading me to Cali I did get a great referral from my regional manager for any openings in LA but I wasn't sure if that's what God would want me to continue to do so I had prayed, "Lord I don't know what you'll have me doing in California but if you want me to work for Clinique I'd really rather work for Nordstrom's than Macy's."

So as I was driving cross country from MN to CA, I stopped at the Oral Roberts University prayer tower in Oklahoma to pray. As I came out my phone rang, and it was the regional director for Clinique in CA calling to invite me to interview. She said the only opening they had for Clinique sales in all of southern CA was at Nordstrom's the Grove which was near Hollywood. So I set up an interview and had a destination.

When I arrived in California I spent my first night in a hotel directly across from Hollywood High School and I spent my first official day in California prayer walking the sunset strip. I was asking God as I was walking where to go next. I said, " Lord, I'm going to run out of money if I keep staying in hotel rooms, so where do you want me to live?" As I

walked I noticed a woman walking in front of me. She had a dress on, but old beat up looking shoes and at one point I had the thought "could she be homeless"? I felt the Holy Spirit nudge me to ask her if she wanted a bottle of water as I had just picked some up from the store. But I blew it off and walked by her. But then I suddenly stopped and walked back to her and said, "I like your sunglasses". Before you know it I shared how I had just arrived and was staying in a hotel figuring out where to live, and she shared that she owned an Airbnb just up the street and that it was half the price per day of what I was spending and the hotel, and next thing I know I was hopping in her old truck and riding with her to show me her place and I moved in the next day. I spent my first 3 months in California living in her Airbnb.

My second day in Hollywood I interviewed with Nordstrom's and got the job and started working the next week. So that's just one story of how praying and letting God lead and following his plans which often make no sense to us ends up being the greatest adventure and making for much better stories than we could write!

The Lord really used my job at Nordstrom's to expose me to so many different cultures and so many ethnicities of women, many of whom were sharing their very personal skin care issues. It was really brilliant of God looking back on it now. The Grove is a favorite tourist destination and people from all over the globe visit and shop there. Talk about scouting out the land and learning to appreciate the diversity of his kingdom.

I got to Cali ready to jump into starting the big vision I came out here with and soon began to hit roadblock after roadblock, obstacle after obstacle, and closed door after closed door. God was clearly showing it wasn't time and instead of soaring and building I was going lower and dying, and dying, and dying a little more to all of the independent attitudes, self-will, self-importance, well basically anything self-driven, and positioned to serve and love and pray. I believe what God has been doing in my life and in his body the church these past seasons is really laying the foundations in prayer and knitting our hearts together as one in preparation for the new kingdom building work he wants to begin. Just

as the scripture says in Psalm 127:1 "Unless the Lord builds the house, they labor in vain who build it." (ESV)

I believe and come in agreement with the words spoken at the Glory of Zion Head of the year 5782 Conference and the word that came forth from Isaac Pitre; "Building the House for the Future". He declared that this is our building season. But Isaac revealed a great truth; before anything can be built on the land you must first clear the land. So I agree that the Lord is clearing our land of every roadblock and obstacle and things the enemy has tried to set in place in our lives to prevent us from rebuilding. And spiritually I believe he is clearing out rooms in our hearts to be positioned to tabernacle with him in new and deeper ways in this new year ahead!

Coincidentally, Glory of Zion in Corinth, TX was my last stop on my way to CA back in 2014 and I attended the Head of the Year 5775 Conference there. So it was another full circle moment of confirmation for me in hearing this message and coming in agreement with this prophetic stream.

I believe we are right now stepping into a great season of building and expansion, co-laboring together to build his kingdom and accomplish the things he has pre-planned to do in and through us, his body, since before the beginning of time! So I believe this is the perfect time God has chosen to launch "Women Fighting Trafficking" to take the land back that the enemy has stolen, to take the children back and to take our families back and build walls of protection around the exploited, abused and vulnerable and weak. To partner with the heart of the true Father who sent his son, the greatest prayer warrior and abolitionist of all time into the world to seek and save the lost, and by the power of his Holy Spirit to set captives free and reclaim and restore them back to life, so that Jesus may receive the reward of his sufferings!

I will close with **Nehemiah 4:14 (AMP)**

"I looked (them over) and rose up and said to the nobles and officials and the other people, do not be afraid of the enemy, (earnestly) remember the Lord and imprint Him (on your minds),

great and terrible, and (take from him courage to) fight for your brethren, your sons, your daughters, your wives, and your homes."

Let's fight trafficking together working with one hand and warring and praying with the other, and let's each get about rebuilding the section of the broken down wall the Lord has put on our heart to repair for him and for his glory!

Lisa Michelle

Lisa Michelle is a voice and advocate for the exploited who has dedicated her life to seeing women and children freed from sexual exploitation. She is the founder of Untethered Ministries, a non-profit that guides women and children into inner-healing from sexual exploitation or trafficking, and Lily & Co. whose curated gifts and products are handcrafted by survivors.

As a survivor herself, Lisa shares her story to the nations so others can find the hope and courage it takes to walk in their own personal freedom. She is an ordained minister and speaks on local and national platforms around the world. Lisa is also a consultant who works with government officials, law enforcement and other agencies educating them on the experiences, traumas and statistics of the exploited.

Lisa, and her husband Jeff, have two beautiful children and two fur babies, and reside in the Texas Hill Country.

Learn more at www.lisamichelle.org

CHAPTER 11

God Healed Me

By: Lisa Michelle

Imagine being born in an abusive home, physically and sexually abused continually during your childhood at the hands of your own father. Then a business man in your neighborhood befriends your mother and she trusts him to let you spend the night in his apartment inside the local mortuary, and the horrors of what happened to you inside those walls drive you into addiction at a young age to alcohol and drugs and living a life on the run.

You end up on the streets of San Francisco, start struggling with mental health challenges and not understanding why you hate yourself and everyone around you. And then an open door leading you to older men opens, learning that you can now use your sexuality as your source of control in your life.

The people who coerced, forced and tricked you into these abusive violent situations have you now on a dangerous path of sexual exploitation and are in control of your future, or so the statistics would say. Please allow me to share my life transformation with you and how God can reach into the most broken places and redeem your story.

You see my childhood was one of survival, it was one I would have liked to have forgotten. My Mom was a waitress and was pregnant at sixteen. My Dad is a bartender, an alcoholic, and a part of the Hells Angels. He was a very violent, angry, abusive man. He would beat my Mom and us kids all the time, so as a child I didn't feel safe and I lived in fear all the time. Like the kind of fear that paralyzes you, the kind where you aren't

sure if you would live to see the next day, kind of fear. My dad also gave me vodka from a very young age before he abused me, so by the time I was twelve I began to drink on my own. I started using drugs, getting into trouble and barely making my grades.

This all left myself and my family vulnerable to a man who lived across the street from us. He was a vile, twisted, perverse man. He was a grandfather type, who ran the local mortuary across the street from our house, a businessman. He gained my mother's trust as she went through escaping my Dad's violence, but this man was a monster, he was a pedophile. And he hid it well from our community. No one knew what went on in those late nights inside that mortuary. Not even myself, until I was in my thirties, when night terrors and flashbacks overtook me and started to haunt me. "It was like going to war but a war you didn't know you were a part of." You see, before every horrific encounter of sexual abuse in this funeral home I was drugged through chocolate chip cookies and lemonade that he gave us. I say us because there were others. Boys too. And his own wife was a victim as well. She was abused in front of us children and drugged herself. I have vivid memories of how he abused her too.

He and his wife had an apartment on top of the funeral home, a part of his job was to keep a close eye on the funeral home itself. What kind of person would want to live with dead people? Just writing that statement gives me chills because there is only one kind I can think of.

Inside of that apartment he had a studio and a dark room where he would process all his pictures and videos he took. I'm sure no one ever saw that room, it was hidden and had his entire life of perversion sitting inside it. He claimed that he was a photographer, that it was a hobby of his but each time I would stay the weekend inside the mortuary he would drug me and sexually exploited me through child pornography AKA in today's terms as child abuse sexual material (CSAM). This was all very devastating to my mental health, because I had no short term memory of what happened to me.

Those years of continual complex sexual trauma led to drug and alcohol addiction, self-harm and living a life of promiscuity trying to fill the void from the pain.

I barely graduated high school when I moved across the country with the first man that really paid attention to me, a drummer of an 80's rock and roll band, he was twelve years older than me. I just turned eighteen. Living the rock and roll lifestyle with bands like Guns and Roses, Poison, Telsa, Great White, The Ramones, etc.

Little did I know heavy drug use and life on the road would consume me, I grew weary and I knew I needed to get help. So I moved back to California. I started waitressing in a diner until I went to school to become a makeup artist.

Desperately trying to stay off of drugs and alcohol I started going to AA (Alcoholics Anonymous) meetings, and started to fight for my recovery. But that didn't last long, on my first day of work as a makeup artist in downtown San Francisco I was invited by a lead makeup artist I was working with (she flew in from Los Angeles) to the underground club scene and the most popular nightclub in SF.

From that night on I transitioned into a lifestyle of clubbing, partying and being a socialite for almost eight years, hanging out with celebrities and living a fast life, diving deeper into my addictions.

Again I came to a point where this lifestyle began to wear me out. I felt empty, hopeless, used and that I had no future. I was in deep pain from within but had no words or way to articulate my experience and I started to do some soul searching (although at the time I had no knowledge of God or what I was searching for), and questioned my lifestyle. I was fully exhausted and had thoughts of, there has to be more to life than this? Sex, drugs, rock and roll.

Then two things happened that changed the destiny of my life!

The first one was a simple invite to church.

I worked in a salon as an esthetician and my sister did nails there. I was walking by her station as she was doing a manicure on a male client of hers. He reached out and grabbed my arm and said, "Hey Lisa, I'd like to invite you to church on Sunday!"

I replied to him, "Me church? Why would you ask a girl like me to church?"

He leaned back in his chair and started laughing and said, "You're right. You are one of the biggest sinners I have met in my life, and you'll

probably catch on fire when you walk through the doors this Sunday. But I know why you'll be coming to church this Sunday."

Intrigued, I asked, "So why would I go to church?"

And he replied, "Because, there are really HOT guys there!"

I looked at my watch and said, "What time does church start? I'll be there!"

Without even thinking about what I was saying yes too.

Then my sister exclaimed, "Not without me you're not going!"

So we showed up to that church on Sunday, for all the wrong reasons, and I went there for a whole year for all the wrong reasons. I dated half the guys there and was sorely disappointed in the guys I was meeting. They were all broken too. But every Sunday I started to hear this message about a father's love that I had never experienced before here on this earth. As a little girl that's all I ever wanted was my Dad to be my Daddy, but he was too stuck in his addiction to know how to be my Dad. The more I heard about this Father, that he accepted me into his kingdom, that he loved me and wanted me and adopted me, I was sold out! I gave my life to the Lord, I got baptized in that church and did a complete 180!

I began to change the way I lived, the way I thought and lost my desire to party and hang out with my partying friends, all by learning the word of God and having a personal relationship with Him! I was also radically delivered from drugs and alcohol and eventually smoking during this time! A true gift after fighting for years before to find my sobriety.

The second thing that happened to me was when I heard a woman speak publicly about being sexually abused. I'll never forget that day because as I listened to this woman say out loud her experience of the sexual abuse she had encountered from her uncle I quickly realized she was giving words to what I had been through. I had never heard such words. And I sat in horror and for the first time as a twenty-eight-year-old woman I realized I had buried a deep secret in my soul as this woman articulated my complex sexual trauma.

At the end of her story she said, if you too have been sexually abused, exploited or trafficked please find someone safe and tell them. So, I

picked up the phone and called my older sister that day and started my healing journey. It was a day of heartbreak and a day of freedom at the same time.

Shortly after this awakening I met my husband at church, yes that same church! A little over a year later we were married and moved to Arizona. I went into a downward spiral mentally after being married. I ended up being diagnosed bio polar, clinically depressed, and under psychiatric care for many years.

One day I felt the Holy Spirit lead me to stop the medication. (I know that's not for everyone and I believe medication is critical and needed in many situations, so please know I am not saying or advocating to not be on medications). I wouldn't be here without those meds. They saved my life and kept me from hurting myself or others.

I knew God supernaturally healed me. I wanted to get pregnant. My psychiatrist was concerned about weaning me off those medications though, but through prayer and trusting that I knew that I knew that I knew, in the year 2000 our son Caleb was born.

And I have been drug free since 1999!

I have been married for twenty-five years and we have two beautiful children. Our son is twenty-one years old and is graduating this year from UTSA with a cyber-security degree! He is the first one on my side of the family to go to college! He made honor roll every semester! And that I am proud is an understatement.

Our daughter is sixteen and she is on Varsity with the dance team in her High School and she's a thriving teenager who loves the Lord! She's determined to get a scholarship and be college bound herself.

Today I am the CEO/Founder of Untethered Ministries, a Non Profit in San Antonio, Texas. Where we see women and children being untethered from exploitation, sexual abuse, shame, fear, poverty, inclusion and more. And become tethered to freedom and their destiny in Christ.

Untethered Ministries serves the at risk population and those who have been sexually abused, exploited or trafficked with a circle of care helping them build sustainable life outside of the life.

NSAGirls, a program within UTM brings gifts filled with hope to women in our local strip clubs, illicit massage businesses, streets and more. Sharing the message that they too can find healing from being sexually exploited and living the life.

I work on legislation at the capitol in Austin, Texas and have worked for a few years inside our juvenile correctional facilities and have seen the needs first hand for victims in need of advocacy and long term healing options. I also serve on various councils and boards working closely with law enforcement, homeland security, Senators, legislators and our Governor's Office Sex Trafficking Team. I'm also the CEO/Founder of Lily & Co., a Social Enterprise partnering with nonprofits globally to bring funding for women and children escaping sexual exploitation.

In Psalm 147:3 it says,

"He heals the brokenhearted and binds up their wounds."

And I believe if God can do this for me, He can do it for you!

I share my story globally and reach the nations now. I am an ordained minister under Patricia King and am amazed at all the Lord has done in my life. My family themselves are always in awe of the places and positions God puts me in. Many I don't have the privilege to share with y'all yet but someday I believe that book will be a bestseller! I've done things that have required me going back into the darkest places of my life to reach into another child's lives to deposit hope in them in their place of sexual exploitation and trafficking. To be a light in some of the darkest places here on earth and having my own lived experience has given me a wealth of expertise that can bring incredible results with survivors in their worst moments in life.

I have been on a fourteen-year journey so far evangelizing and ministering to the exploited and providing desperate resources when needed. It's amazing seeing women and children's lives transformed just by saying yes and crossing what I call, a line of fear and stepping into my destiny leading so many others can cross over into their healing paths. It has

brought a deeper level of healing to my soul and has brought beauty from ashes in my life.

So if you too have been sexually abused, assaulted, exploited or trafficked know that you can find healing and hope as well. To not give up, to press forward in your fight for your sanity and sobriety. On the other side of your pain is purpose and there will be a day you cross the line of fear and you will see and taste this freedom I speak of! Please don't ever give up on your dreams. Focus on God, His words and not any man here on earth. And press on towards the goal of knowing that "You may have been born into your circumstances but you don't have to remain hostage to them."

If you want to learn more about the work I do and how to support our efforts please go www.lisamichelle.org and join us in the fight! Lisa Michelle.

Polly Walshin

I am a southern girl at heart, living in San Diego for over 20 years. I have two amazing children now, ages 24 and 21. I live right around the corner from my mom who has been my rock my entire life. I am now happily married to a wonderful man. I wrote this book knowing that it was time for me to reinvent myself not just as being a mom, but to inspire others that could use my mess in my own life and help others not make the same mistakes.

I graduated from The American College with a degree in Interior Design, in Atlanta, Georgia. I spent the first couple of years out of college working for a large Model Home company and designed over 100 homes for many different builders. My family and I were growing and we decided to move to San Diego. I spent the next 10 years as a homemaker and decided to put my career on hold to be with my children.

When I became a single mother my oldest was seven and my youngest was five. I got my real estate license. When the market crashed in 2006 my real estate career took off. I sold over $10 million worth of real estate in a matter of two years just by knocking door-to-door and helping people get out of their homes without foreclosure.

I also helped open many LA fitness's all over San Diego. I was their number one producer while still managing to be able to be there for my children for everything as a single mother.

pmwalshin@gmail.com

CHAPTER 12

Daddy Issues

By: Polly Walshin

You're probably wondering why in the world a chapter called daddy issues is in a book about being sex trafficked. Well my friend having daddy issues has everything to do with self-esteem and vulnerability. That low self-esteem and vulnerability many times leads you down the road to the things you would've never done if you would've known how your father in heaven honestly loves you. That identity crisis we have inside us allows us to accept behavior from others that we wouldn't if we knew our true value. I'm not saying that being sex trafficked is a choice by any means. Sometimes it happens by force and by surprise by kidnapping or many other horrific injustices. I am saying that how you feel about yourself and your self-worth can put you in situations you would not be in if you got how truly perfect and unique you are!

What ever happened with your Dad as a child wasn't about you. Most issues with Dads come from how they grew up or how they feel about themselves and have nothing to do with you not being good enough, or pretty enough, or smart enough. You are enough.

My story is long and you can read it in my book which is called, "Daddy Issues" which really describes how you see yourself as a direct reflection of many of the choices you make in your life. Until you finally see one day that you have a Father in heaven that loves you so much and only wants the best for you. Remember the devil comes to steal, kill and destroy and especially destroy our identity.

I'll take you back to the story of my mom and dad where it all started. My mom is from a very small town in Arkansas. When she met my dad he was this handsome pilot, successful, charming man. They went on a few dates and on one of the dates he was very abusive to my mom. After that she didn't want to see him ever again so she thought. My mom was a beautiful woman and she had many suitors. After her horrific experience with my Dad she started dating some other man. He was a prince to the throne in Saudi Arabia and was going to college at Arkansas State University. My mom described him as a dark-haired, handsome, really good looking guy that adored her and she knew she could move from that small town. She could already tell that he wanted to control everything. At that point she didn't really care; she just wanted to be married and out of that small town. My dad heard that my mother was getting married. One night he watched the movie, "The Graduate" and he knew after seeing it that he had to stop my Mom from marrying this other guy. He said there was no way that he could allow my mom to marry anyone but him.

He showed up at my grandparents' house and told my Papa that he didn't care what he had to say that he was going to marry my mother. He called my mom and she answered the phone reluctantly because she had a lot of anger from their dating time that they had. He said you need to show up at the airport with your toothbrush and a gown. My mom actually did that, she showed up at the airport with a toothbrush and a gown and they flew to Oklahoma City and got married that day. Before they left she went by her fiancés apartment and left a note with her engagement ring. I often wonder what happened to that guy or what my life would've been like if she would have married him.

Needless to say the marriage to my Dad wasn't even close to perfect. My dad was a very abusive man physically and mentally to my mom and he was a habitual cheater. When I was six months old my mom had finally had it. She literally saw his car at the local hotel in town and he was shacked up with some lady and that was it for her she got her little girl Polly and she left. She went and got her own place in Little Rock and within three days she was working a great job and had a nanny. She started to date some here and there. My mom was very driven but she

had a lot of her own emotional scars she did not work through that happened to her as a child So she found her good feelings about herself by doing an amazing job at her job and working twice as hard as everyone else. Mom hardly had a social life outside of work her whole life was dedicated to providing for me and being an amazing Mom.

She did date one man, his name was Charlie for about 6 months when I Was 4. I did not remember any of the abuse that happened to me by him until I was 20. I was in a human sexuality class and the man that was the guest speaker had been molested and he was telling his story. I remember sitting in that auditorium in my white hippie skirt and my bleached brown hair from surfing and just feeling sick to my stomach when I heard his story. I can still remember the room, the smell, the temperature of the air, the dimness of the lights like it was yesterday and that was 30 years ago. I had no idea why I was feeling so sick and so moved by his story. After the lecture I went up to the man and told him how touched I was by his story. I believe that was one of 100s of divine encounters in my life. He asked me well why did that touch you so much like he knew something I didn't. I remember blinking super-fast and not understanding why I felt so sick. That man gave me free therapy and led me on the road to recovery from that horrible incident I had suppressed for years. When I went to therapy he introduced me to this wonderful woman named Gloria. She was about 56 and had red hair like my mothers and I just felt I could trust her. In my therapy session she asked me to close my eyes and she did hypnotism. That was a way for me to mentally scan different areas of my body and when she got to my throat area I literally hit the floor in the fetal position. After I came to the floor I was sobbing because I remembered everything that that man Charlie did to me at age 4. I had locked that trauma in my throat. This is a type of therapy that has you focus on different areas of your body to see if you feel different sensations in your mind as you visually scan your body. See we hold trauma and pain in different areas of our body.

Charlie used to come into my room at night and choke me and tell me that if I ever told my mother what he was doing to me that he would kill her and I would have to live with him. That is why I hit the floor

when we got to my throat in therapy. I had locked all that trauma there. I never told my mother I put that so deep inside of me that that incident created the beginning of me having two sides to my personality. One that was pretty Polly and was a people pleaser and the other one that was Wilder rebellious Polly. I was trying to always numb out the pain.

Now at this point in my early childhood years my Dad would only come to visit a few times over the course of 6 years. He was married to a new woman and a new family: my half brother and sister. He had no time for me and my Mom was super protective of me being around him. My last memory of my Dad before he mysteriously passed away was at an airport. My mom woke me up and put on my little pink nightgown, I had my curlers in my hair and I remember we had a brown Ford LTD. My Mom sat me on the armchair next to her about three and about 3 in the morning we drove to the airport. I saw my dad's jet pull up. He got out of the airplane with his chinchilla coat, Rolex, and frizzy permed 70s hair. I remember feeling so happy to see him from afar. My mom had me stay in the car and he just waved to me, he gave my mom just a little bit of money so that she could get by. This is the only time he had ever given her really any child support when I was 6. She had been raising me and taking care of me this whole time with very little money from him. That day she said, "Honey, we're gonna be fine now." She tells me it was only $1500. Wow that's literally $200 a year for my whole life that he gave to her. Even back then the feeling of unworthiness was there.

It was almost a year later on a rainy day in the south. It was the day of my birthday party for the Reverend Dr. Sutherland who showed up at my house. Now I had just given my life to Jesus and did the walk down to the altar just three months before. So when I saw him I was so excited to have the Reverend at my house. He was not there for any ordinary visit that day. I thought he was coming to say happy birthday but that is not why he was there. He sat me down on the brown furry sofa in my mom 's house and said I need to tell you something. It was raining outside and a bit chilly. My Mom had a fire burning as I sat in anticipation of what he was going to tell me. He said, "Your father has committed suicide he jumped off the White River bridge and he is no

longer alive." That was not the news I was expecting at all. As a little girl, especially a little girl that knew how to stuff her emotions from my own trauma I had been through just 2 years before I just looked at him and said. "What are we gonna do now?" He said, "Sweetheart all you can do is pray I'm here for you no matter what and so is Jesus." The little girl that was four years old just showed up at that moment and knew to shut everything off. I immediately went to my room and just started playing with my Barbies. I spent 24 hours in my room that day not eating, not doing anything, not sleeping, just playing with my Barbie's. I believe in that moment that's when I learned to really disconnect from everything.

That's what predators look for: they look for women and men that know how to disassociate from themselves so that they can manipulate them into bad situations. I spent the next 10 years going to Christian school but living in an OK neighborhood with kids that did not go to Christian school. I would go to Christian school and be a good little Polly and I would come home and smoke pot and be promiscuous with my neighborhood BMX friends. I had so much shame from that that I never told my Mom. Because of those choices and dealing with all that pain, I was almost raped, I was stabbed, I almost got put into foster care because a neighbor lied about my Mom.

When I was almost 16 and I was starting to make better choices we were home in England Arkansas. On the front of the England gazette was the article that truly changed the course of my life. There was my dad Lazarus. I went home to visit my family in the small town I was raised in. On the front page of the paper there was, Garry Wayne Betzner indicted for the possession of 1000 kg of cocaine in Lake City Florida. I couldn't believe my dad was alive! I had so many questions and wondered, "Where has he been?"

Betzner arrested in Florida by Federal Narcotics Agents Tuesday

Gary Wayne Betzner, a former Hazen resident who supposedly jumped from the White River Bridge in Des Arc in 1977, was arrested by federal drug enforcement officials at Gainesville, Florida Tuesday afternoon, November 20.

Betzner is now in the custody of the U. S. Marshal at Jacksonville, Florida and being held without bond. At the time of his arrest, he had approximately 400 pounds of cocaine in his possession. Officials were unable to even estimate the street value of the drug.

Sheriff Dale Madden was notified by the Federal Bureau of Investigation last Tuesday that Betzner was in custody. He is being sought by Prairie County officials for possession of a controlled substance with intent to deliver and also with intent to manufacture. The charges stemmed from a raid by police authorities on his home in Hazen on September 9, 1977. He was arrested and released on $15,000 bond pending plea day proceedings at DeValls Bluff on September 19 in Circuit Court. The night before the hearing, he stopped on the bridge at Des Arc about midnight, handed his wife a note purportedly suicidal, and disappeared.

Betzner had previously been indicted by a federal grand jury in Philadelphia in May of that year along with five others. The indictment charged conspiracy to distribute cocaine. He was scheduled to stand trial on those charges in Miami, Florida on October 3, 1977.

A federal warrant for his arrest by the Federal Bureau of Investigation was issued on October 18, 1977 on grounds of unlawful flight to avoid prosecution after dragging and searching operations on the White River failed to turn up his body.

That year was my senior in high school and my mom was so successful at Federal Express she did not want the humiliation or interrogation of anyone to know what had happened. That year we moved to New York my Mom gat a great job and I started modeling. We had always lived in the south in a sort of bubble and now I was in the big city. I remember wanting to model and I figured out how to get skinny quick anorexia. I believe this was the beginning of real self-sabotage. I didn't understand anything with my dad I hadn't dealt with the molestation and I was just lost. My mother did take me down to Florida to visit Dad in prison and I got to hug him and he told me he was so sorry that he left but I think inside I wondered why in the world did you leave me for so long and not let me know? Back then some part of me blamed my mother but now I know my mom never knew either and she actually protected me all those years from anything bad thank God for her.

After my senior year and a few modeling jobs we moved to California now that was my hippy days. I got to California. I was still modeling and I got turned onto a killer band called the Grateful Dead. My very first show I went to, someone gave me ecstasy and then that moment I thought I loved everybody and I had finally found my tribe. I spent the

next three years traveling all over the country selling juice, selling acid, selling T-shirts, doing whatever I could to get to the next show. I did not think I had an addiction to drugs I just would do anything I got my hands on frankly somehow I fit school in between Tour and I got my associates degree in 91at Orange coast college. That is where I heard the lecture that made me remember my trauma from when I was 4. My life was wild to say the least and if you buy my book Daddy Issues you can read all my crazy commune in Hawaii, living with the Krishna's, dating a convict, making hash, skinny dipping, sweat lodge stories, soul train dancer, cocaine parties, Ice t back u dancer.

After my last crazy adventure my Mom said we are done with California you're not gonna make it I got to get you away from all these crazy hippies. So we literally opened the map and pointed with our finger at where we were going to move and we ended up in Atlanta. In the beginning Atlanta was awesome. We were much closer to my Grandparents and all my family. I was going to the University of Georgia, I met my best friend Alison. I was kind of doing some really cool hippie things. I was relatively happy. I moved back to Atlanta from Athens, GA after going to UGA and pretty much failing all my classes after a year and a half. I moved in with my boyfriend and I didn't know what a problem he had with drugs until we moved to the big city together. I was working at nightclubs cocktail waitressing and going to school. My mom did not want me immersed into that life so I moved in with her for a little while and used my modeling skills I got in New York to enter into a pageant. That was the carrot my Mom used to try to help me see my value and get out of the rut I was in. I did not win but I got my head right to think that wow I don't have to be a crazy hippie anymore and do drugs and work in a shitty bar I could actually be pretty Polly again. I didn't even know what balance meant.,

I started doing lots of modeling gigs. I started out by doing Miller cold patrol girls, then Jagermeister girls, I was Miss Jim Beam. I did lots and lots of ads and then I knew if I got my boobs done, I could make more money. I didn't quite have a boyfriend yet and one of the guys I dated was the producer for the band Boys to Men. He brought the band

to my Mom's living room to serenade me when I was recovering from my boob job. I guess I didn't see what a gentleman he was nor did I like myself enough to know that I deserved a great guy like him. Then I met my kid's dad while I was signing autographs for Miss Jim beam. I did a couple of NASCAR ads and I became Miss Dixie Speedway and miss NASCAR. My boyfriend and I would go down to Florida and I would do a bikini contest and win. We would have enough money so that I wouldn't have to work a real job because I was still in college. He had his own way of making money too.

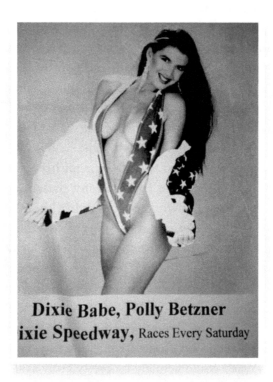

Dixie Babe, Polly Betzner
ixie Speedway, Races Every Saturday

Then my girlfriend said, "why don't you try out at the strip bar?" I don't know why I didn't think that was not a big deal but literally I was already wearing a G string all the time to win money in bikini contests so what was taking off my clothes was my thinking. I started working at a bar in Atlanta called 'The Cheetah'. I justified it because I had to be weighed to work, the guys weren't allowed within 3 feet of any of the

workers, and we weren't allowed to drink more than one drink at a time. I was making in three days $2000 a week without hardly doing anything. I learned in that experience because I didn't know how important and how valuable my body was and that my body really is the temple of the Holy Spirit. I didn't think anything of just taking my clothes off for just any stranger because I didn't really care about myself like that. I hadn't really dealt with my core issues yet.

See, trafficking sometimes just happens really slowly and you don't even know it's happening. It's all about desensitizing you to accept more and more lewd things. It's like a slow drip on a faucet and before you know it the whole basement is flooded. If you're reading this and somehow this strikes a chord with you I'm asking you as a friend, as a mother, as a sister to please find someone that you can talk to! There is a way out. I was one of the lucky ones I just quit one day when I was graduating from college. I just never went back to work. I said to myself, "I just can't do this anymore," and I did graduate from college. I paid for my school and I was one of the lucky ones.

I can't tell you how many of my friends never got out and they just graduated from being a stripper to being a hooker and now they're in abusive relationships. That's pretty much the pattern that happens in that world. I called them and prayed for them on the phone all the time. You have a Father in heaven that loves you more than you could ever imagine and you are worthy of the best life that He has for you. I want you to know that He says you're precious, and perfect just the way you are and He loves you. Whatever trauma happened to you when you were younger or whatever happened with your own Dad as a child please know that none of that was God's plan for your life. I have forgiven my dad and the man that molested me. I am happily married now. I have 2 grown kids that are my world and are successful. I live right down the street from my Mom and we talk 3 or 4 times a day. I own a spa business in San Diego called I sweat Lodge come visit!!

www.isweatlodge.com

I'm an author and a speaker to many organizations about the importance of fathers and their impact on children's lives. None of this was possible without prayer and Jesus lots and alot of Jesus and a community of believers that have prayed me through my darkest days You don't have to have a roller coaster life like I did before you finally get it together and let go and let God. You can turn what was meant for evil for good. Just know that YOU ARE WORTH IT!!!

Please go get a copy of my book Daddy Issues. It's on amazon or my website at *www.yougotdaddyissues.com*

I love you. YOU GOT THIS !!

Sharelle Mendenhall

Sharelle is a multi-talented and multifaceted leader with incredible levels of vision, anointing, and capacity. While some of her highest recognition has come in the form of holding the title of "beauty queen" as former Miss California and current Mrs. Nevada, her other achievements include actress, model, photographer, producer, and being a self-starter business woman with multiple successful businesses. Sharelle has gained knowledge and wisdom that come from hard work, resilience, and the ability to adapt to change. Through life experience, she understands what it takes to persevere and overcome challenges and obstacles. The way she loves, fights for, and champions others is infectious and inspiring as she continuously contends to see people walking out their God given freedom, destiny, and purpose. She has been no stranger to trials and hardship which has only led to her profound love of people and desire to serve. Sharelle executes with excellence, tenacity, grit, and passion—her mission always being to serve and honor God with every gift, talent, opportunity, and ability He has given her.

sharelle18@yahoo.com

Declare War on Human Trafficking

By: Sharelle Mendenhall

Every 30 seconds a child goes missing – A national emergency needs to be called. My name is Sharelle Mendenhall and I have declared war on human trafficking. This is an issue that needs to be of the highest priority. Programs and laws must be instituted nationwide in order to bring down this giant. I'm sure some of you have seen the signs on the back of bathroom stall doors meant to serve as educational collateral and prevention. It's one step in the right direction, but is this enough? While posters and signs can aid in bringing awareness, they are limited in their ability to truly equip those who are targeted with tangible tools that could not only impact, but save their very lives. Equipping starts at the core.

One reason why it is so easy for these crimes to take place is that kids are being left alone and don't have programs in place to offer protection, or develop their identity, purpose, and independence. Media, influencers, and "culture" are raising our kids, often creating deep seeded comparison and a sense of unworthiness, fear, and even anxiety all perpetuated by the desire to feel accepted and seen. This also sets them up for exposure as targets for potential harm. While the base of a secure identity and feeling of belonging begin in the home, sadly, most of the youth that are impacted by human trafficking come from the foster system. Based on a study by (Business Insider-National Foster Youth Institute) it is said that "it is estimated that 60% of CSEC victims have a history in the child welfare system." In this study, their long-term objective in order to aid in

the defeat of trafficking is this: "Reformation of how the foster care system manages the supervision of kids, such as removing them completely by the age of 18, must happen to ensure more potential targets aren't being created for traffickers."

Las Vegas has been known worldwide as one of the biggest offenders of Human Trafficking. What if we turn that around and make Las Vegas the example of how to fight this epidemic? We need to start with an executable plan here and share our successes nationwide.

Beyond reformation of these systems, there also must be proper legislative initiatives put forth that help educate children and parents about the statistics of child victims of sex and human trafficking, especially those in more vulnerable populations such as Nevada. While this education could be conducted through after-school meetings by educators and school district officials and through community outreach events by local law enforcement, the principles should be an extension of truth administered through an often-quiet entity. Which is right now, why I'm going to call out the church.

One reason why the world is educating our kids with massive agendas is because the church isn't. Go ahead and tell me that I'm wrong, I'll wait. I'm not talking about once a year vacation Bible school, church camp held for a few days every summer, or even good stories on a weekly basis. While these are good in nature and serve a purpose of reinforcement of what God says about them, they don't offer the tools that serve the individual on a daily basis in a way that they know how to apply on their own to combat all the negativity and false information served up by culture, and then help change it. A more structured and consistent, yet tangible approach is needed.

What would happen if the churches had an after-school program that is both biblical and practical? Programs that help draw out the skills and potential of our children and equip them to succeed. Programs that teach kids to plan out what they want, to build a team, and then go out and build it. Or teach kids how to work on cars, to bake, to stand in front of a group and speak, or to be involved in planning, prepping, and executing a vision. What if the church was the biggest advocate for our

children and created the necessary structure to help them not only have a profound sense of purpose and thrive in society through the teaching of substantial life-skills, but be the very catalysts for change in it? What if it also offered the education and awareness of human trafficking? It can be by giving them a place that strengthens their identity, nurtures the very gifts and talents they naturally possess, and then educates and supports them in the use and pursuit of such abilities and endeavors.

What would happen if we started focusing on teaching kids through TikTok, YouTube and Snapchat? These sources reach some of the most vulnerable and we need to take advantage of these tools. We have let this go on for far too long and have treated the symptoms and not addressed the root cause. Neglecting the kids and not providing resources for them to learn and thrive is on us. They are our future and we need to ensure that we protect them. It's time we cancel this epidemic.

According to the national congregational study survey there are an estimated 380,000 churches in the US. These should all be structured as a 501© (3) or nonprofit where people can donate and lend their expertise to make these programs a reality! I am not asking them to build something completely new. We have hundreds of thousands of churches with buildings to walk this vision out, it simply is a matter of structuring a plan and proper implementation. I plan to work with these leaders to make it happen—A coalition to empower kids and train them in the way they should go while also providing a refuge for them.

Now, while this all may seem a bit grandiose, in essence it is a necessity. We may not fully be able to see just how big an issue that human trafficking really is, but it is one that can no longer be ignored or minimized. Realizing that children are the most targeted is a part of it, however, we must also understand that like any other crime committed, trafficking can have incredible impact on any community as a whole. The numbers are beginning to prove this—it no longer can be about the one missing woman, or the one missing youth, it is about the family and the community that is also affected.

DATA & STATS:

Local Level: Las Vegas-Clark County

Many Americans, whether locals or tourists, might believe that prostitution is legal in Las Vegas, which is within Clark County. This couldn't be further from the truth. Prostitution is illegal in Clark County because its population exceeds 700,000, mainly because Las Vegas is a predominant city within the county. Public perception is important because if there is misinformation about whether prostitution is legal or not in Las Vegas, it stifles the urgency to address human trafficking. Within the Las Vegas Metropolitan Police Department, there have been increased efforts cracking down on sex trafficking in the Las Vegas Strip. In April this year, an undercover vice operation resulted in multiple arrests on the Las Vegas Strip and the Southern Nevada Human Trafficking Task Force has remained vigilant in continuing to fight this issue.

Las Vegas is known as the entertainment capital of the world, attracting both domestic and foreign tourists to visit the city. While this should be a celebrated factor of our city, it also presents unique challenges to combatting human trafficking. The challenges are that there are major events happening that attract tourists which leads to a spike in human trafficking. Major events can lead to greater opportunities for perpetrators to target potential victims. There have been ongoing debates in past years on whether the largest sporting event in America, the Super Bowl, brings forth a major spike in sex trafficking activities. It's been found (2019) that with increased demand for manual labor, sex for hire, and other services among major sporting events, increases in reported human trafficking around the Super Bowl are evident. This should concern those of us living in the Las Vegas community now with the possibility of Allegiant Stadium hosting the Super Bowl in 2024.

The Las Vegas Metropolitan Police Department currently has a unit directly responsible for combating this problem within the city. The Vice and Sex Trafficking Investigations Section is responsible for investigating

Human Trafficking cases. Their responsibilities include arresting traffickers, protecting victims, and assisting them in the recovery process.

State Level: Nevada

In the state of Nevada, prostitution is considered legal by state law but there are legal boundaries that many are not aware of. On his main website, criminal defense lawyer Benjamin Nadig highlights that prostitution is only legal in Nevada counties that comprise of a population with less than 700,000 people. Since Las Vegas is within Clark County and the Las Vegas metropolitan area alone has a population of over 2.3 million people, prostitution is illegal in Clark County. Outside of the metropolitan area of the city, the population of Las Vegas is currently over 660K, which, when combined with other Clark County city populations equals out to over 700,000 people. Nevada state government Assemblywoman Lisa Krasner proposed Assembly Bill 143, a bill, if passed, creating a statewide human trafficking task force that could open provide the state access to federal grants. This proposition came after findings from the National Human Trafficking Hotline in 2019 showed that the amount of sex trafficking cases in the state of Nevada exceeded the national average.

Federal Level: Across the Nation

According to the DOJ (2020) vulnerable targets for traffickers include American Indians, LGBTQ questioning individuals, disabled individuals, illegal immigrants, runaway/homeless youth, temporary guest workers and low-income individuals. Victims in human trafficking can be found in a plethora of different situations, which is important concerning legislative efforts to combat it. The DOJ (2020) reported that victimization occurs in child care, elder care, the drug trade, massage parlors, nail and hair salons, restaurants, hotels, factories, and farms. Exploitation is also known to occur amongst street prostitution, illicit massage parlors, cantinas, brothels, escort services, and online advertising. During the COVID-19 pandemic in 2020, human trafficking

Human trafficking is defined as "the recruitment, transportation, transfer, harboring, or receipt of persons by improper means for an improper purpose including forced labor or sexual exploitation" (Impact NV). Those "improper means' ' include force, coercion, abduction, or fraud. (United Nations definition) Therefore, whether we want to accept it or not, prostitution is a big part of the problem and main form of human trafficking. More education is needed to help those in public service be better equipped and aware of the signs of victimhood when encountering victims. For more on this, I highly recommend reading the study entitled "Failing Victims? Challenges of the Police Response to Human Trafficking". The study found that "whenever officers work a sex trafficking case during routine duties, they might not have the proper training to reach the actual human trafficking unit. This prevents the appropriately trained officers from getting access to this case, delaying justice and restoration for the victims of traffickers." This also led to a disconnect in trust between the officers and the victims under the perception that the victim's claims are false in regards to rape as there are too many false claims made or the victim feels like their case is being pushed off and their trauma is delegitimize.

Our Objectives:

1. To legislate for all states to form their own Sex Trafficking Multidisciplinary Teams.
2. To move for human trafficking to become a national emergency.
3. Create collaborations with influencers, production teams, current after school programs and churches that are focused on healthy development and growth of children at risk of being trafficked. Done properly we can instill confidence in these individuals, give practical tools and eradicate this disease.
4. Direct funding from the national emergency to create a team that travels around school to school and eventually state to

126

state. The entire purpose is to educate kids of all warning signs, empower them and equip teachers with the resources to combat this within their classroom.

Cited research by Cameron Gilbert.

Works Cited Page:

1) Shoro, M. (2019, February 08). New team forms to fight sex trafficking in Las Vegas Valley. Retrieved October 5, 2021, from *https://www.reviewjournal.com/crime/sex-crimes/new-team-forms-to-fight-sex-trafficking-in-las-vegas-valley-1592069/*

2) Contrera, Jessica (2021, August 26). Sex-trafficked kids are crime victims. In Las Vegas, they still go to jail., Retrieved October 5, 2021, from *https://www.washingtonpost.com/dc-md-va/interactive/2021/vegas-child-sex-trafficking-victims-jailed/*

3) Pasley, James (2019, July 25). 20 Staggering Facts about human trafficking in the U.S., Retrieved October 5, 2021, from *https://www.businessinsider.com/human-trafficking-in-the-us-facts-statistics-2019-7*

4) Retrieved October 4, 2021 *https://www.benjaminnadig.com/need-know-prostitution-laws-nevada/*

5) Cipriano, Andrea (2019, August 1). Police are 'Failing' Human Trafficking Survivors: Study., Retrieved October 4, 2021, from *https://thecrimereport.org/2019/08/01/police-are-failing-human-trafficking-survivors-study/*

CHAPTER 14

<div style="text-align:center">⟨≈≫⟩</div>

...In Closing

By: Kelly R Patterson

As the authors of Freedom Cry, the collaboration for this book was undertaken because we are in agreement that trafficking is a horrendous crime against humanity, we are determined to help those affected by this crime, we are dedicated to educating others, and we believe faith is the most important key in the healing journey.

God has never promised that we won't get hurt in this life, but He has promised to walk it out with us if we come to Him. Psalm 34:17-19 says "The righteous cry, the Lord hears and delivers them out of all their troubles. The Lord is near to the brokenhearted and saves those who are crushed in spirit. Many are the afflictions of the righteous. But the Lord delivers them out of them all."

"Many"—did you notice that term? The word "many" is a big word. In the original Hebrew language this word is רַב (rab) which means much, many, great, great in number, especially plural, substantial, many times.

The word "afflictions" is also a big word. In the original Hebrew, this word is רַע (rah) which means bad, unpleasant, giving pain, unhappiness, misery, evil days (of trial and hardship), malignant, bad, disagreeable. In other words, when this passage says "..many are the afflictions.." that is exactly what it means but to an even larger extent than people want to believe. The message has been watered down today to say that believers should not suffer anything difficult—not illness, not financial difficulties, not persecution, etc. Where do we get this doctrine? Certainly not

from the Word of God! If that were true, there would be no martyrs, there would be no need for faith, and there would be no need for prayer.

Note that this passage is referring to the righteous. Those who were or still are captive to pimps and traffickers are not unrighteous in what they are being forced to do or have been forced to do. The unrighteous are those selling and those buying these precious ones. In fact, many who are forced into this slavery are born again believers. Yet, untold damage is done to their relationships with God as it is the traffickers goal to dehumanize and steal the identity of their victims. Real healing from this brokenness takes true miracles of love.

As believers around the globe learn to reach out and to love these injured souls, the more these survivors can begin to love themselves. Finding a way to accept love from others is the beginning to self-acceptance. Self-acceptance will aid those on the journey to continue steadfastly and not give up. If they cannot accept themselves as worthy of love or kindness, the journey stagnates or may even stop cold.

Unfortunately, the most common way individuals judge themselves is by acceptance or rejection from others. Escaping that life is the first step of an exceptionally long journey ahead. Though it is the biggest step to being alive, it is for many, only one step of remaining alive. While suicide is a big problem when captive, it can be an even greater issue for some once freed. Choosing life can be an everyday battle for many. Built into the traffickers' relentless programming are a series of mental and emotional tapes that speak words of death. These "recordings" must be discovered and dealt with in order to progress forward.

Additionally, some survivors of trafficking must hide much of the rest of their lives from those who kept them captive against their will whether through force, fraud, or coercion. Often they need to seek a new identity, leave everyone and everything they know and start over.

These dear ones come to us, the Body of Christ, to be genuinely loved as they are. They have often been treated as though they did not matter, and therefore believe the lie that they do not matter. On the other end of that pendulum, some are treated as though they mattered too much—specifically in conjunction with sexual activity. In this case,

the belief may be that their body is what makes them special or important. Persistent body image issues may develop from that previous treatment which replays the lie that says "I am my body".

Often a spouse or parents may be involved in the trafficking. When this occurs, the survivor will generally be left with even larger feelings of worthlessness and not being valued. God is looking for His followers to come alongside these souls in the gift of wisdom, adoration, and cherishing of these wounded ones. Survivors of any sexual trauma generally carry the shame as if it is theirs to carry, when in fact this shame belongs to the perpetrator(s).

Due to the many dynamics in the life after life, God is calling His army to love the fragile, the broken, the unlovable, the angry, the bitter, the hateful, the prickly, the ungrateful, the scarred, the lost, and the chaotic. These are just a few examples of the many complications accompanying these modern-day martyrs. Nothing is more healing to those wounds than pure love served humbly on platters held by the servants of Almighty God.

Do you hear their collective cry? The cries of those whose innocence has been stolen. They cry out from the alleyways, brothels, playgrounds, strip clubs, prison cells, locked doors, windowless vans, city streets, mansions, homeless camps, basements, hotels, airplanes, and on and on—please listen carefully with your heart tuned in to their cries. It is deafening. It is heartbreaking. It is gut wrenching. They are crying for someone, for anyone, to help.

Are you ready? Yes! Yes, you are! You did not pick up this book and read to the end for no reason. You are here, right now, for a purpose. What is your place in this war zone? Position yourself to hear the heartbeat of the Father, the cry of the Son, and the beckoning of the Holy Spirit. They call to all who will listen.

As abolitionists, it is our corporate cry for those who have read this book to take what you have read and join the battle with us. We need the heart cries of faithful prayer warriors to surround us in our efforts and the efforts of others to accomplish anything. It is our belief that nothing apart from prayer will help us to continue in this work. We need you. They need you.

There are numerous ways to join us. Many of us seek the help of volunteers who wish to physically enter the battlefield with us. The need is endless for individuals to bring their creativity and giftings. For instance, we are looking for various professional services to come alongside our programs in areas such as medical, legal, dental, counselors/therapists, pastors, cooks, photographers, computer techs, tattoo cover-ups/removal, security, hair stylists, and nutritionists.

Statistically, the criminal networks are growing and winning in this realm. It must not remain this way—it cannot remain this way. This trend must not continue. God's people must arise to defeat this beast. Let us lock arms and defeat the enemy's plot to destroy the souls of humanity. Help us break the shackles of human slavery. Join us in this freedom cry!

LET'S BEGIN...

CPSIA information can be obtained
at www.ICGtesting.com
Printed in the USA
JSHW040921120523
41620JS00004B/26